THIS JOURNAL
BELONGS TO:

"The main thing is to be moved, to love, to hope, to tremble, to live."
—Auguste Rodin

THE MET

On the cover:

A Bouquet of Flowers in a Crystal Vase
Nicolaes van Veerendael, Flemish, 1640–1691
Bequest of Stephen Whitney Phoenix, 1881 81.1.652

All works are from the collection of The Metropolitan Museum of Art.

ISBN: 978-1-4197-2425-1

Printed and bound in China
10 9 8 7 6 5 4 3 2 1

Abrams Noterie products are available at special discounts when purchased in quantity for premiums and promotions as well as fundraising or educational use. Special editions can also be created to specification. For details, contact specialsales@abramsbooks.com or the address below.

ABRAMS The Art of Books
115 West 18th Street, New York, NY 10011
abramsbooks.com

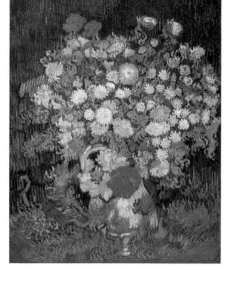

*Bouquet of
Flowers in a Vase*

Vincent van Gogh,
Dutch, 1853–1890

20＿＿ _____

20＿＿ _____ 20＿＿ _____

_____ _____

_____ _____

_____ _____

20＿＿ _____ 20＿＿ _____

_____ _____

_____ _____

_____ _____

JANUARY

2

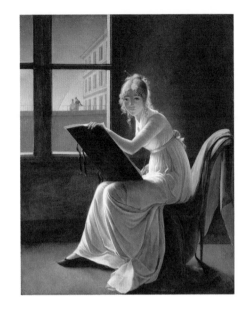

Charlotte du Val d'Ognes (died 1868)

Marie Denise Villers, French, 1774–1821

Mr. and Mrs. Isaac D. Fletcher Collection, Bequest of Isaac D. Fletcher, 1917 17.120.204

20___ _____

20___ _____ 20___ _____

_____ _____

_____ _____

_____ _____

20___ _____ 20___ _____

_____ _____

_____ _____

_____ _____

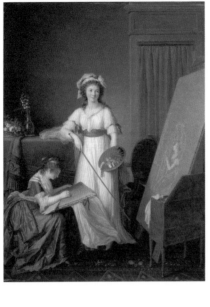

*The Interior of an
Atelier of a
Woman Painter*

**Marie Victoire
Lemoine,** French,
1754–1820

Gift of Mrs. Thorneycroft
Ryle, 1957 57.103

20__ _____

20__ _____ 20__ _____

_____ _____

_____ _____

_____ _____

20__ _____ 20__ _____

_____ _____

_____ _____

_____ _____

JANUARY

4

**Three Friezes
with Ornamental
Foliage**

**Designed and
engraved by
Enea Vico,** Italian,
1523–1567

Harris Brisbane Dick
Fund, 1953 53.600.46

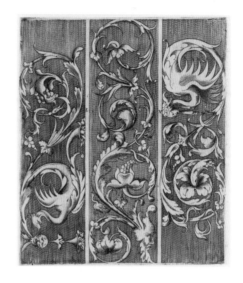

20__ _____

20__ _____ 20__ _____

_____ _____

_____ _____

20__ _____ 20__ _____

_____ _____

_____ _____

***Dish in the Shape
of a Leaf***

Chinese, Tang dynasty
(618–907)

Purchase, Arthur M. Sackler
Gift, 1974 1974.268.11

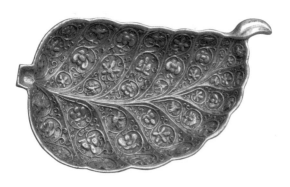

20__ _____

20__ _____ 20__ _____

_____ _____

_____ _____

_____ _____

20__ _____ 20__ _____

_____ _____

_____ _____

_____ _____

15, rue Maître-Albert

Eugène Atget,
French, 1857–1927

Rogers Fund, 1991
1991.1233

20__ _____

20__ _____ 20__ _____

_____ _____

_____ _____

_____ _____

20__ _____ 20__ _____

_____ _____

_____ _____

_____ _____

Vase of Flowers and Conch Shell

Anne Vallayer-Coster, French, 1744–1818

Gift of J. Pierpont Morgan, 1906 07.225.504

20__ _____

20__ _____ 20__ _____

_____ _____

_____ _____

_____ _____

20__ _____ 20__ _____

_____ _____

_____ _____

_____ _____

Large Boston Public Garden Sketchbook: Two women conversing on the street

Maurice Brazil Prendergast, American, 1858–1924

Robert Lehman Collection, 1975 1975.1929

20__ _____

20__ _____ 20__ _____

20__ _____ 20__ _____

忠臣蔵八段目

歌麿筆

Two Tori-oi, or Itinerant Women Musicians of the Eta Class

Kitagawa Utamaro,
Japanese, 1753?–1806

Gift of the Estate of Samuel
Isham, 1914 JP998

20_ _ _____

20_ _ _____

20_ _ _____

20_ _ _____

20_ _ _____

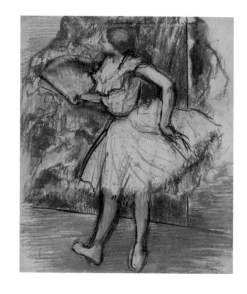

Dancer with a Fan

Edgar Degas,
French, 1834–1917

H. O. Havemeyer
Collection, Bequest of
Mrs. H. O. Havemeyer,
1929. 29.100.557

20___ _____

20___ _____ 20___ _____

_____ _____

_____ _____

_____ _____

20___ _____ 20___ _____

_____ _____

_____ _____

_____ _____

The Dance Class
Edgar Degas,
French, 1834–1917

Bequest of Mrs. Harry
Payne Bingham, 1986
1987.47.1

20__ _____

20__ _____ 20__ _____

_____ _____

_____ _____

_____ _____

20__ _____ 20__ _____

_____ _____

_____ _____

_____ _____

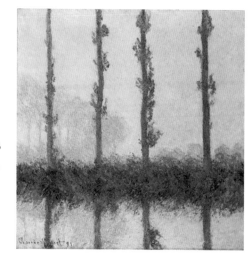

The Four Trees
Claude Monet,
French, 1840–1926

H. O. Havemeyer
Collection, Bequest of
Mrs. H. O. Havemeyer,
1929 29.100.110

20___ _____

20___ _____ 20___ _____

_____ _____

_____ _____

_____ _____

20___ _____ 20___ _____

_____ _____

_____ _____

_____ _____

Sketchbook of a Journey to the Château d'Eu

Pierre François Léonard Fontaine,
French, 1762–1853

Gift of The Apollo Circle, in honor of Philippe
de Montebello, 2008 2008.337a-ee

JANUARY

13

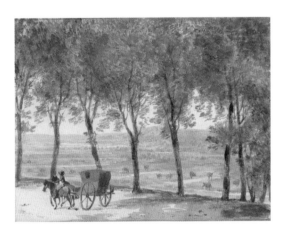

20_ _ _____

20_ _ _____ 20_ _ _____

_____ _____

_____ _____

_____ _____

20_ _ _____ 20_ _ _____

_____ _____

_____ _____

_____ _____

Still Life with Teapot and Fruit

Paul Gauguin, French, 1848–1903

The Walter H. and Leonore Annenberg
Collection, Gift of Walter H. and Leonore
Annenberg, 1997, Bequest of Walter H.
Annenberg, 2002 1997.391.2

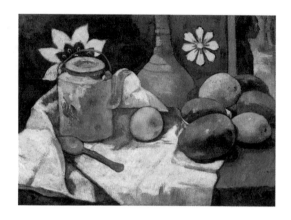

20___ _____

20___ _____ 20___ _____

_____ _____

_____ _____

_____ _____

20___ _____ 20___ _____

_____ _____

_____ _____

_____ _____

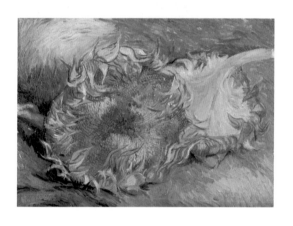

20__ _____

20__ _____ 20__ _____

_____ _____

_____ _____

_____ _____

20__ _____ 20__ _____

_____ _____

_____ _____

_____ _____

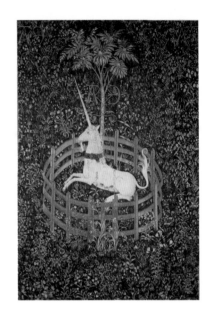

The Unicorn in Captivity from the **Unicorn Tapestries**

South Netherlandish, 1495–1505

Gift of John D. Rockefeller Jr., 1937 37.80.6

20_ _ _____

20_ _ _____ 20_ _ _____

_____ _____

_____ _____

_____ _____

20_ _ _____ 20_ _ _____

_____ _____

_____ _____

_____ _____

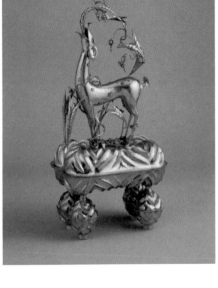

Jewel Box

Dagobert Peche,
Austrian, 1887–1923

Manufactured by
Wiener Werkstätte,
Austrian, 1903–1932

Purchase, Anonymous
Gift, 1978 1978.8a–c

20__ _____

20__ _____ 20__ _____

_____ _____

_____ _____

_____ _____

20__ _____ 20__ _____

_____ _____

_____ _____

_____ _____

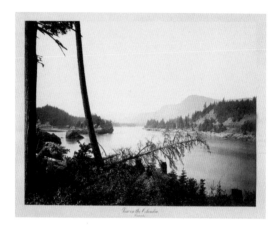

View on the Columbia, Cascades

Carleton E. Watkins, American, 1829–1916

Warner Communications Inc. Purchase Fund and Harris
Brisbane Dick Fund, 1979 1979.622

20_ _ _____

20_ _ _____ 20_ _ _____

_____ _____

_____ _____

_____ _____

20_ _ _____ 20_ _ _____

_____ _____

_____ _____

_____ _____

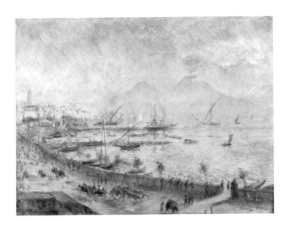

The Bay of Naples
Auguste Renoir, French, 1841–1919

Bequest of Julia W. Emmons, 1956 56.135.8

20_ _ _____

20_ _ _____ 20_ _ _____

_____ _____

_____ _____

_____ _____

20_ _ _____ 20_ _ _____

_____ _____

_____ _____

_____ _____

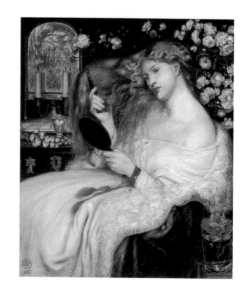

Lady Lilith

Dante Gabriel Rossetti, British, 1828–1882

Henry Treffry Dunn, British, 1838–1899

Rogers Fund, 1908 08.162.1

20_ _ _____

20_ _ _____ 20_ _ _____

_____ _____

_____ _____

_____ _____

20_ _ _____ 20_ _ _____

_____ _____

_____ _____

_____ _____

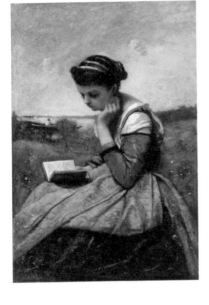

A Woman Reading
Camille Corot,
French, 1796–1875

Gift of Louise Senff
Cameron, in memory
of her uncle, Charles H.
Senff, 1928 28.90

20__ _____

20__ _____ 20__ _____

_____ _____

_____ _____

20__ _____ 20__ _____

_____ _____

_____ _____

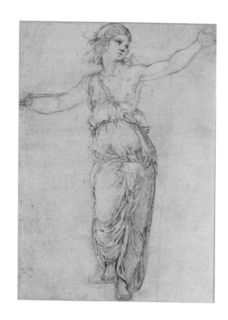

Lucretia

Raphael, Italian,
1483–1520

Purchase, Lila Acheson
Wallace Gift, 1997
1997.153

20__ _____

20__ _____

20__ _____

20__ _____

20__ _____

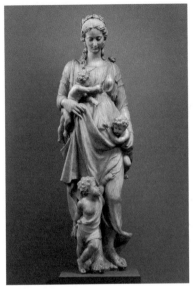

Charity

Circle of Jacques du Broeucq, ca. 1500–1584

Purchase, Josephine Bay Paul and C. Michael Paul Foundation Inc. Gift and Charles Ulrick and Josephine Bay Foundation Inc. Gift, 1965 65.110

20__ _____

20__ _____

20__ _____

20__ _____

20__ _____

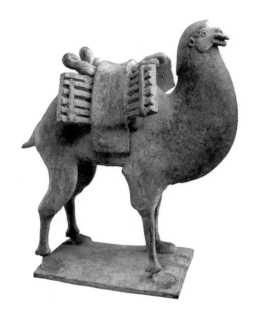

Camel

Chinese, Northern
Wei (386–534)–
Northern Qi
(550–77) dynasty

Rogers Fund, 1928 28.121

20__ _____

20__ _____ 20__ _____

_____ _____

_____ _____

20__ _____ 20__ _____

_____ _____

_____ _____

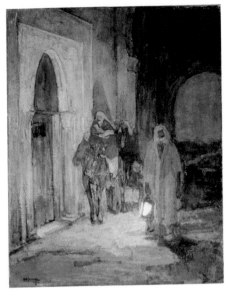

Flight Into Egypt
**Henry Ossawa
Tanner,** American,
1859–1937

Marguerite and Frank A.
Cosgrove Jr. Fund, 2001
2001.402a

20__ _____

20__ _____ 20__ _____

_____ _____

_____ _____

_____ _____

20__ _____ 20__ _____

_____ _____

_____ _____

_____ _____

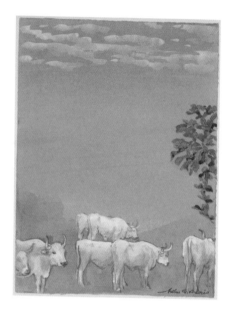

Landscape with Cows

Arthur B. Davies,
American, 1862–1928

Bequest of Susan Dwight
Bliss, 1966 67.55.137

20__ _____

20__ _____ 20__ _____

_____ _____

_____ _____

20__ _____ 20__ _____

_____ _____

_____ _____

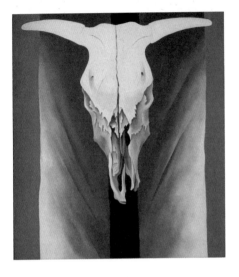

Cow's Skull: Red, White, and Blue

Georgia O'Keeffe, American, 1887–1986

Alfred Stieglitz Collection, 1952 52.203

20__ _____

20__ _____ 20__ _____

_____ _____

_____ _____

20__ _____ 20__ _____

_____ _____

_____ _____

*Matilda Stoughton
de Jaudenes*

Gilbert Stuart,
American, 1755–1828

Rogers Fund, 1907 07.76

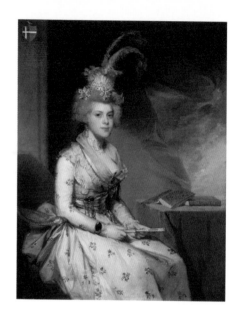

20＿＿ _____

20＿＿ _____ 20＿＿ _____

_____ _____

_____ _____

_____ _____

20＿＿ _____ 20＿＿ _____

_____ _____

_____ _____

_____ _____

Pillow cover

Candace Wheeler,
American, 1827-1923

Gift of Candace Pullman
Wheeler, 2002 2002.355.1

20_ _ _____

20_ _ _____ 20_ _ _____

_____ _____

_____ _____

_____ _____

20_ _ _____ 20_ _ _____

_____ _____

_____ _____

_____ _____

Black Stork in a Landscape

British, ca. 1780

Louis E. and Theresa S. Seley Purchase Fund for Islamic Art and Rogers Fund, 2000 2000.266

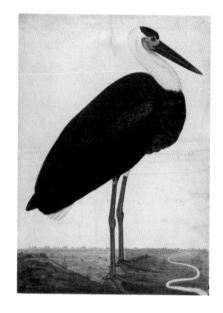

20＿＿ _____

20＿＿ _____ 20＿＿ _____

_____ _____

_____ _____

_____ _____

20＿＿ _____ 20＿＿ _____

_____ _____

_____ _____

_____ _____

Watch Pin

Riker Brothers,
American, active
1892–1926

Purchase, Susan and Jon
Rotenstreich Gift, 2001
2001.331

20__ _____

20__ _____ 20__ _____

_____ _____

_____ _____

_____ _____

20__ _____ 20__ _____

_____ _____

_____ _____

_____ _____

FEBRUARY

1

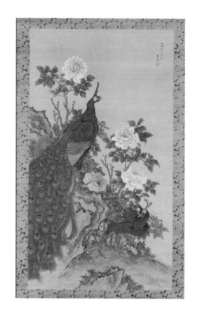

Peacocks and Peonies

Tani Bunchō,
Japanese, 1763–1840

Charles Stewart Smith
Collection, Gift of Mrs.
Charles Stewart Smith,
Charles Stewart Smith
Jr., and Howard Caswell
Smith, in memory of
Charles Stewart Smith,
1914 14.76.51

20__ _____

20__ _____

20__ _____

20__ _____

20__ _____

Pink and Rose
William Morris,
British, 1834–1896

Purchase, Edward C.
Moore Jr. Gift, 1923
23.163.4a

20_ _ ————————————

————————————————

————————————————

20_ _ —————————— 20_ _ ——————————

—————————————— ——————————————

—————————————— ——————————————

—————————————— ——————————————

20_ _ —————————— 20_ _ ——————————

—————————————— ——————————————

—————————————— ——————————————

—————————————— ——————————————

Portrait of the Elephant 'Alam Guman

Painting attributed to Bichitr, active ca. 1610–1660

Harris Brisbane Dick Fund, 1996 1996.98a

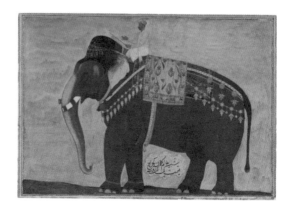

20_ _ _____

20_ _ _____ 20_ _ _____

_____ _____

_____ _____

20_ _ _____ 20_ _ _____

_____ _____

_____ _____

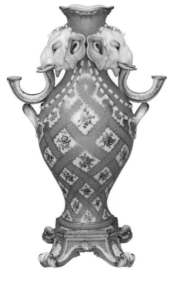

*Vase (vase à tête
d'éléphant)
(one of a pair)*

**Jean-Claude
Duplessis,** French,
ca. 1695–1774, active
1748–1774

Sèvres Manufactory,
French, 1740–present

Gift of Samuel H.
Kress Foundation, 1958
58.75.90a, b

20___ _____

20___ _____ 20___ _____

_____ _____

_____ _____

20___ _____ 20___ _____

_____ _____

_____ _____

_____ _____

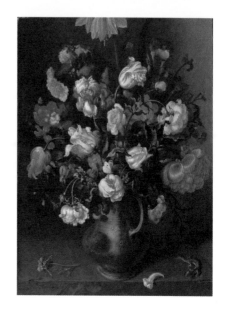

A Vase with Flowers

Jacob Vosmaer,
Dutch, ca. 1584–1641

Purchase, 1871 71.5

20＿＿ _____

20＿＿ _____ 20＿＿ _____
_____ _____
_____ _____
_____ _____

20＿＿ _____ 20＿＿ _____
_____ _____
_____ _____
_____ _____

Flower Study, Rose of Sharon
Adolphe Braun, French, 1811–1877

Gift of Gilman Paper Company, in memory of Samuel J. Wagstaff Jr., 1987 1987.1161

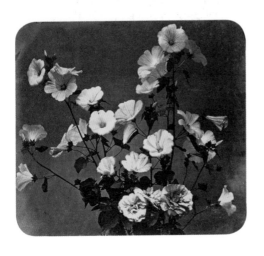

20__ _____

20__ _____ 20__ _____

_____ _____

_____ _____

_____ _____

20__ _____ 20__ _____

_____ _____

_____ _____

_____ _____

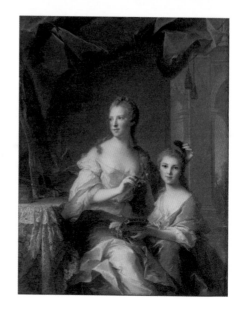

*Madame Marsollier
and Her Daughter*

Jean Marc Nattier,
French, 1685–1766

Bequest of Florence S.
Schuette, 1945 45.172

20＿＿ _____

20＿＿ _____ 20＿＿ _____

_____ _____

_____ _____

_____ _____

20＿＿ _____ 20＿＿ _____

_____ _____

_____ _____

_____ _____

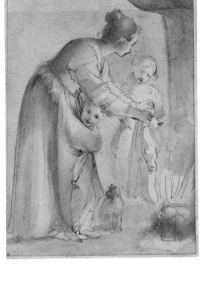

A Domestic Scene
Annibale Carracci,
Italian, 1560–1609

Purchase, Mrs. Vincent
Astor and Mrs. Charles
Payson Gifts, Harris
Brisbane Dick and Rogers
Funds, 1972 1972.133.2

20_ _ _____

20_ _ _____ 20_ _ _____

_____ _____

_____ _____

_____ _____

20_ _ _____ 20_ _ _____

_____ _____

_____ _____

_____ _____

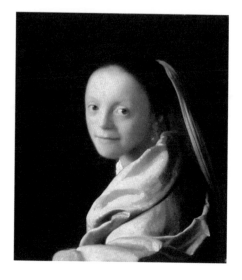

Study of a Young Woman

Johannes Vermeer, Dutch, 1632–1675

Gift of Mr. and Mrs. Charles Wrightsman, in memory of Theodore Rousseau Jr., 1979
1979.396.1

20__ _____

20__ _____ 20__ _____

_____ _____

_____ _____

20__ _____ 20__ _____

_____ _____

_____ _____

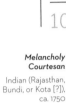

Melancholy Courtesan

Indian (Rajasthan, Bundi, or Kota [?]), ca. 1750

Purchase, Evelyn Kranes Kossak and Josephine L. Berger-Nadler Gifts and funds from various donors, 1995 1995.232

20_ _ _____

20_ _ _____ 20_ _ _____

_____ _____

_____ _____

_____ _____

20_ _ _____ 20_ _ _____

_____ _____

_____ _____

_____ _____

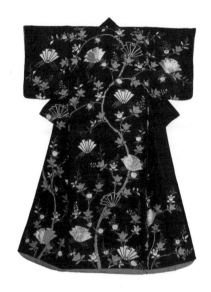

*Outer Robe
(Uchikake) with
Mandarin Oranges
and Folded-Paper
Butterflies*

Japanese, late 18th–
early 19th century

Gift of Ilse Bischoff, 1976
1976.108

20＿＿ _____

20＿＿ _____ 20＿＿ _____

_____ _____

_____ _____

_____ _____

20＿＿ _____ 20＿＿ _____

_____ _____

_____ _____

_____ _____

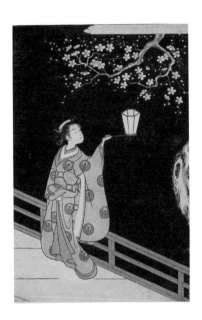

*Woman Admiring
Plum Blossoms
at Night*

Suzuki Harunobu,
Japanese,
1725–1770

Fletcher Fund, 1929
JP1506

FEBRUARY

12

20__ _____

20__ _____ 20__ _____

_____ _____

_____ _____

_____ _____

20__ _____ 20__ _____

_____ _____

_____ _____

_____ _____

13

Masqueraders

Raimundo de Madrazo y Garreta, Spanish, 1841–1920

Robert Lehman Collection, 1975 1975.1.233

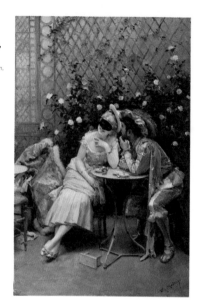

20__ _____

20__ _____ 20__ _____

_____ _____

_____ _____

_____ _____

20__ _____ 20__ _____

_____ _____

_____ _____

_____ _____

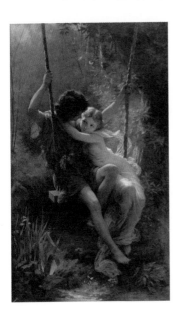

20__ _____

20__ _____ 20__ _____

_____ _____

_____ _____

_____ _____

20__ _____ 20__ _____

_____ _____

_____ _____

_____ _____

Genius of Mirth

Thomas Crawford,
American, 1813?–1857

Bequest of Annette W. W.
Hicks-Lord, 1896 97.13.1

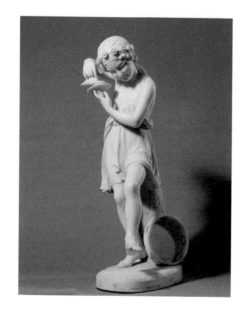

20＿＿ _____

20＿＿ _____ 20＿＿ _____

_____ _____

_____ _____

20＿＿ _____ 20＿＿ _____

_____ _____

_____ _____

The Little Fourteen-Year-Old Dancer

Edgar Degas,
French, 1834–1917

H. O. Havemeyer Collection,
Bequest of Mrs. H. O.
Havemeyer, 1929 29.100.370

20__ _____

20__ _____ 20__ _____

_____ _____

_____ _____

_____ _____

20__ _____ 20__ _____

_____ _____

_____ _____

_____ _____

Peony

Wang Wu, Chinese, 1632-1690

Bequest of John M. Crawford Jr., 1988
1989.363.140

20＿＿ _____

20＿＿ _____ 20＿＿ _____

_____ _____

_____ _____

_____ _____

20＿＿ _____ 20＿＿ _____

_____ _____

_____ _____

_____ _____

Still Life: Vase of Peonies

Edmund Charles Tarbell, American, 1862–1938

Gift of Mrs. J. Augustus Barnard, 1979 1979.490.1

20__ _____

20__ _____ 20__ _____

_____ _____

_____ _____

_____ _____

20__ _____ 20__ _____

_____ _____

_____ _____

_____ _____

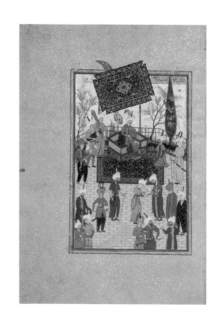

"Khusrau Seated on his Throne", Folio from a *Khamsa (Quintet) of Nizami*

Nizami (Ilyas Abu Muhammad Nizam al-Din of Ganja), probably 1141–1217,

Gift of Alexander Smith Cochran, 1913 13.228.7.4

20__ _____

20__ _____ 20__ _____

_____ _____

_____ _____

_____ _____

20__ _____ 20__ _____

_____ _____

_____ _____

_____ _____

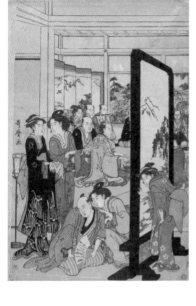

**The Artist Kitao
Masanobu Relaxing
at a Party**

Kitagawa Utamaro,
Japanese, 1753?–1806

The Francis Lathrop
Collection, Purchase,
Frederick C. Hewitt Fund,
1911 JP737

20__ _____

20__ _____ 20__ _____

_____ _____

_____ _____

20__ _____ 20__ _____

_____ _____

_____ _____

Modern Rome

Giovanni Paolo Panini, Italian, 1691–1765

Gwynne Andrews Fund, 1952 52.63.2

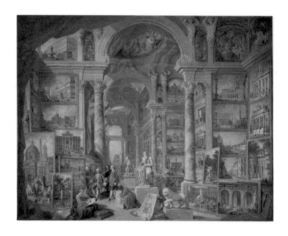

20__ _____

20__ _____ 20__ _____

_____ _____

_____ _____

_____ _____

20__ _____ 20__ _____

_____ _____

_____ _____

_____ _____

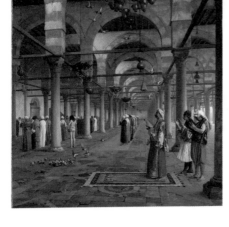

Prayer in the Mosque

Jean-Léon Gérôme,
French, 1824–1904

Catharine Lorillard Wolfe
Collection, Bequest of
Catharine Lorillard Wolfe,
1887 87.15.130

20_ _ ⎯⎯⎯⎯⎯⎯⎯⎯⎯⎯⎯⎯⎯⎯

⎯⎯⎯⎯⎯⎯⎯⎯⎯⎯⎯⎯⎯⎯⎯⎯⎯⎯⎯⎯⎯

⎯⎯⎯⎯⎯⎯⎯⎯⎯⎯⎯⎯⎯⎯⎯⎯⎯⎯⎯⎯⎯

20_ _ ⎯⎯⎯⎯⎯⎯⎯ 20_ _ ⎯⎯⎯⎯⎯⎯⎯

⎯⎯⎯⎯⎯⎯⎯⎯⎯⎯⎯⎯ ⎯⎯⎯⎯⎯⎯⎯⎯⎯⎯⎯⎯

⎯⎯⎯⎯⎯⎯⎯⎯⎯⎯⎯⎯ ⎯⎯⎯⎯⎯⎯⎯⎯⎯⎯⎯⎯

⎯⎯⎯⎯⎯⎯⎯⎯⎯⎯⎯⎯ ⎯⎯⎯⎯⎯⎯⎯⎯⎯⎯⎯⎯

20_ _ ⎯⎯⎯⎯⎯⎯⎯ 20_ _ ⎯⎯⎯⎯⎯⎯⎯

⎯⎯⎯⎯⎯⎯⎯⎯⎯⎯⎯⎯ ⎯⎯⎯⎯⎯⎯⎯⎯⎯⎯⎯⎯

⎯⎯⎯⎯⎯⎯⎯⎯⎯⎯⎯⎯ ⎯⎯⎯⎯⎯⎯⎯⎯⎯⎯⎯⎯

⎯⎯⎯⎯⎯⎯⎯⎯⎯⎯⎯⎯ ⎯⎯⎯⎯⎯⎯⎯⎯⎯⎯⎯⎯

Office in a Small City
Edward Hopper, American, 1882–1967

George A. Hearn Fund, 1953 53.183

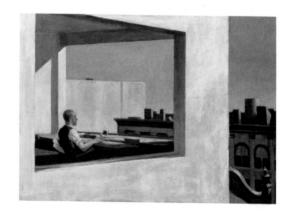

20_ _ _____

20_ _ _____ 20_ _ _____

_____ _____

_____ _____

_____ _____

20_ _ _____ 20_ _ _____

_____ _____

_____ _____

_____ _____

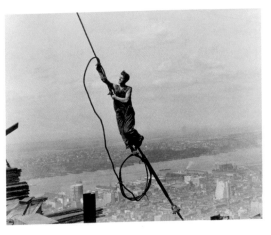

Icarus, Empire State Building
Lewis Hine, American, 1874–1940

Ford Motor Company Collection, Gift of Ford Motor
Company and John C. Waddell, 1987 1987.1100.119

20__ _____

20__ _____ 20__ _____

_____ _____

_____ _____

_____ _____

20__ _____ 20__ _____

_____ _____

_____ _____

_____ _____

Marble grave stele of a little girl

Greek, Classical Period

Fletcher Fund, 1927 27.45

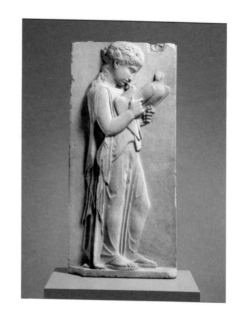

20__ _____

20__ _____ 20__ _____

_____ _____

_____ _____

_____ _____

20__ _____ 20__ _____

_____ _____

_____ _____

_____ _____

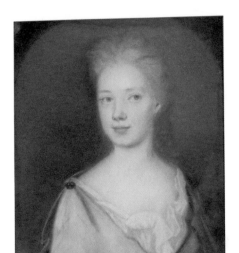

*Mrs. Pierre Bacot
(Marianne Fleur
Du Gue)*

Henrietta Johnston,
ca. 1674–1729

Gift of Mrs. J. Insley Blair,
1947 47.103.23

20__ _____

20__ _____ 20__ _____

_____ _____

_____ _____

_____ _____

20__ _____ 20__ _____

_____ _____

_____ _____

_____ _____

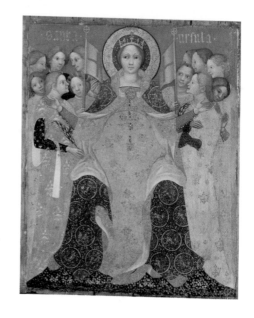

Saint Ursula and Her Maidens

Niccolò di Pietro,
Italian, active
1394–1427/30

Rogers Fund, 1923 23.64

20__ _____

20__ _____ 20__ _____

_____ _____

_____ _____

_____ _____

20__ _____ 20__ _____

_____ _____

_____ _____

_____ _____

Portrait of a Woman
British, ca. 1600

Gift of J. Pierpont Morgan,
1911 11.149.1

20__ ————————————————
————————————————————————
————————————————————————

20__ —————————— 20__ ——————————
—————————————— ——————————————
—————————————— ——————————————

20__ —————————— 20__ ——————————
—————————————— ——————————————
—————————————— ——————————————

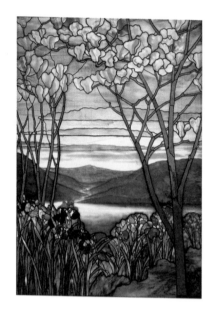

Magnolias and Irises

Louis Comfort Tiffany,
American, 1848–1933

Tiffany Studios,
American, 1902–1932

Anonymous Gift, in memory
of Mr. and Mrs. A. B. Frank,
1981 1981.159

20__ _____

20__ _____ 20__ _____

_____ _____

_____ _____

20__ _____ 20__ _____

_____ _____

_____ _____

Wild Roses and Irises

John La Farge,
American, 1835–1910

Gift of Priscilla A. B.
Henderson, in memory of
her grandfather, Russell
Sturgis, a founder of The
Metropolitan Museum of
Art, 1950 50.113.3

20__ _____

20__ _____ 20__ _____

_____ _____

_____ _____

_____ _____

20__ _____ 20__ _____

_____ _____

_____ _____

_____ _____

The Dancing Class

Edgar Degas, French, 1834–1917

H. O. Havemeyer Collection, Bequest of Mrs. H. O. Havemeyer, 1929 29.100.184

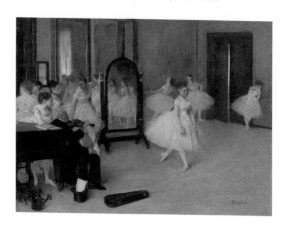

20__ _____

20__ _____ 20__ _____

_____ _____

_____ _____

_____ _____

20__ _____ 20__ _____

_____ _____

_____ _____

_____ _____

The Rehearsal Onstage

Edgar Degas, French, 1834–1917

H. O. Havemeyer Collection, Bequest of Mrs. H. O. Havemeyer, 1929 29.100.39

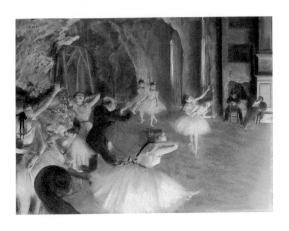

20_ _ _____

20_ _ _____ 20_ _ _____

_____ _____

_____ _____

_____ _____

20_ _ _____ 20_ _ _____

_____ _____

_____ _____

_____ _____

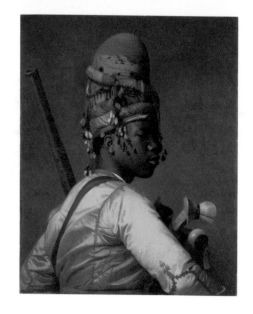

Bashi-Bazouk

Jean-Léon Gérôme, French, 1824–1904

Gift of Mrs. Charles Wrightsman, 2008
2008.547.1

20＿＿ _____

20＿＿ _____

20＿＿ _____

20＿＿ _____

20＿＿ _____

20＿＿ _____

20＿＿ _____

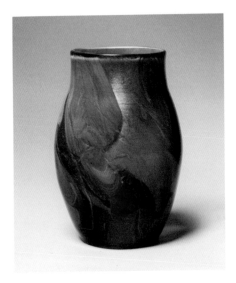

Vase

Louis Comfort Tiffany, American, 1848–1933

Tiffany Furnaces, American, 1902–1920

Gift of Louis Comfort Tiffany Foundation, 1951
51.121.10

20__ _____

20__ _____ 20__ _____

_____ _____

_____ _____

_____ _____

20__ _____ 20__ _____

_____ _____

_____ _____

_____ _____

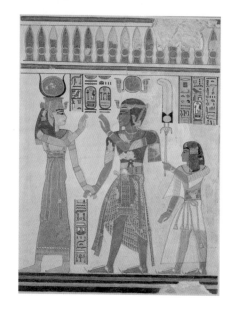

*Ramesses III
and Prince
Amenherkhepeshef
before Hathor*

**Nina de Garis
Davies,** 1881–1965

Original from Egypt,
ca. 1184–1153 B.C.,
facsimile created
in 1933

Rogers Fund, 1933 33.8.7

20__ __ _____

20__ __ _____ 20__ __ _____

20__ __ _____ 20__ __ _____

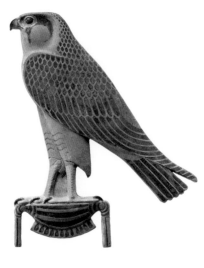

20__ _____

20__ _____ 20__ _____
_____ _____
_____ _____

20__ _____ 20__ _____
_____ _____
_____ _____

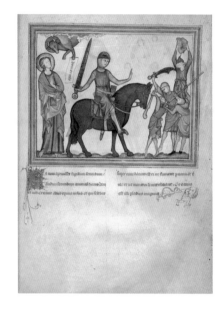

Page from Manuscript of *The Cloisters Apocalypse*

French (Normandy), ca. 1330

The Cloisters Collection, 1968 68.174

20__ _____

20__ _____ 20__ _____

_____ _____

_____ _____

_____ _____

20__ _____ 20__ _____

_____ _____

_____ _____

_____ _____

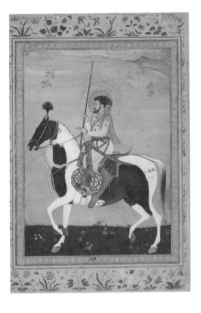

Shah Jahan on Horseback

Folio from the *Shah Jahan Album*

Payag, Indian, active ca. 1591–1658

Purchase, Rogers Fund and The Kevorkian Foundation Gift, 1955 55.121.10.21

20__ _____

20__ _____ 20__ _____

20__ _____ 20__ _____

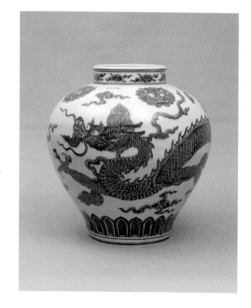

Jar with Dragon

Chinese, Ming
Dynasty (1368–1644),
Xuande mark and
period (1426–35)

Gift of Robert E. Tod,
1937 37.191.1

20__ _____

20__ _____ 20__ _____

_____ _____

_____ _____

20__ _____ 20__ _____

_____ _____

_____ _____

*Knotted Dragon
Pendant*

Chinese, Shang
dynasty (ca.
1600–1046 B.C.)

Gift of Ernest Erickson
Foundation, 1985
1985.214.99

20__ _____

20__ _____ 20__ _____

20__ _____ 20__ _____

Plaque with Censing Angels

French, ca. 1170–1180

The Cloisters Collection, 2001 2001.634

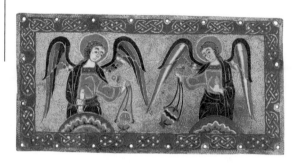

20_ _ _____

20_ _ _____ 20_ _ _____

_____ _____

_____ _____

_____ _____

20_ _ _____ 20_ _ _____

_____ _____

_____ _____

_____ _____

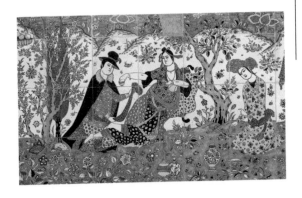

20__ _____

20__ _____ 20__ _____

_____ _____

_____ _____

_____ _____

20__ _____ 20__ _____

_____ _____

_____ _____

_____ _____

The Angel of Death and the Sculptor from the Milmore Memorial

Daniel Chester French, American, 1850–1931

Gift of a group of Museum trustees, 1926 26.120

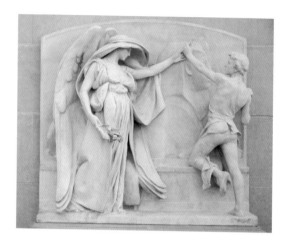

20__ _____

20__ _____ 20__ _____
_____ _____
_____ _____
_____ _____

20__ _____ 20__ _____
_____ _____
_____ _____
_____ _____

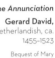

The Annunciation

Gerard David,
Netherlandish, ca.
1455–1523

Bequest of Mary
Stillman Harkness, 1950
50.145.9ab

20_ _ _____

20_ _ _____ 20_ _ _____

_____ _____

_____ _____

_____ _____

20_ _ _____ 20_ _ _____

_____ _____

_____ _____

_____ _____

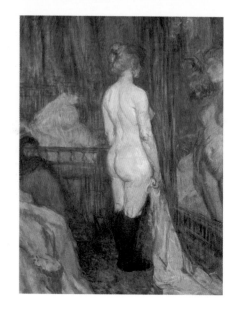

Woman before a Mirror

Henri de Toulouse-Lautrec, French, 1864–1901

The Walter H. and Leonore Annenberg Collection, Bequest of Walter H. Annenberg, 2002 2003.20.15

20＿＿ _____

20＿＿ _____

20＿＿ _____

20＿＿ _____

20＿＿ _____

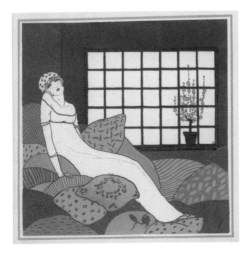

*Les Choses de
Paul Poiret*

Georges Lepape,
French, 1887–1971

Museum Accession,
transferred from the
Library 1978.671.6

20__ _____

20__ _____ 20__ _____

_____ _____

_____ _____

_____ _____

20__ _____ 20__ _____

_____ _____

_____ _____

_____ _____

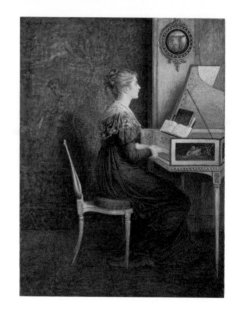

An Old Song

William John Hennessy, Irish, 1839–1917

Purchase, Gift of George A. Lucas and Bequest of George D. Pratt, by exchange, 1982 1982.314

20_ _ _____

20_ _ _____ 20_ _ _____

_____ _____

_____ _____

_____ _____

20_ _ _____ 20_ _ _____

_____ _____

_____ _____

_____ _____

Grand Pianoforte
Érard and Co.,
British, ca. 1840

Gift of Mrs. Henry
McSweeney, 1959 59.76

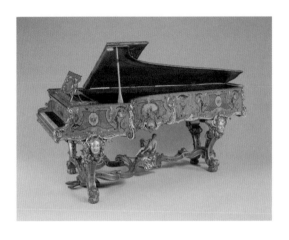

20__ _____

20__ _____ 20__ _____

_____ _____

_____ _____

_____ _____

20__ _____ 20__ _____

_____ _____

_____ _____

_____ _____

Finches and Bamboo

Emperor Huizong, Chinese, 1082–1135; r. 1100–1125

John M. Crawford Jr. Collection, Purchase, Douglas Dillon Gift, 1981 1981.278

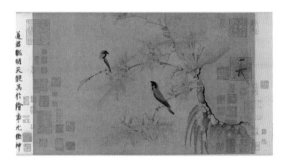

20__ _____

20__ _____ 20__ _____

_____ _____

_____ _____

_____ _____

20__ _____ 20__ _____

_____ _____

_____ _____

_____ _____

Brooch

Dagobert Peche,
Austrian, 1887–1923

Wiener Werkstätte

Purchase, Edward C.
Moore Jr. Gift, 1924
24.242.2

20__ _____

20__ _____

20__ _____

20__ _____

20__ _____

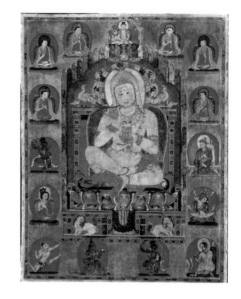

Portrait of Jnanatapa Attended by Lamas and Mahasiddhas

Tibetan (Riwoche Monastery), ca. 1350

Purchase, Friends of Asian Art Gifts, 1987 1987.144

20＿＿ _____

20＿＿ _____

20＿＿ _____

20＿＿ _____

20＿＿ _____

*Buddha, probably
Amitabha (Amituofo)*

Chinese, Tang dynasty
(618–907)

Rogers Fund, 1919 19.186

20_ _ _____

20_ _ _____ 20_ _ _____

20_ _ _____ 20_ _ _____

Still Life with Peaches and Grapes
Auguste Renoir, French, 1841–1919

The Mr. and Mrs. Henry Ittleson Jr. Purchase Fund, 1956 56.218

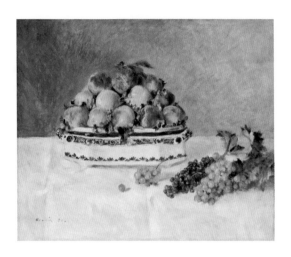

20_ _ _____

20_ _ _____

20_ _ _____

20_ _ _____

20_ _ _____

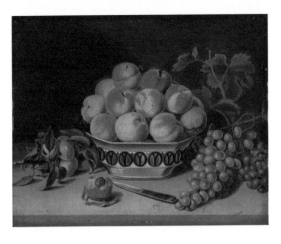

Still Life: Peaches and Grapes
John A. Woodside, American, 1781–1852

Rogers Fund, 1941 41.152.1

20_ _ _____

20_ _ _____ 20_ _ _____

_____ _____

_____ _____

_____ _____

20_ _ _____ 20_ _ _____

_____ _____

_____ _____

_____ _____

*Manuel Osorio
Manrique de
Zuñiga (1784–1792)*

Francisco de Goya,
Spanish, 1746–1828

The Jules Bache
Collection, 1949 49.7.41

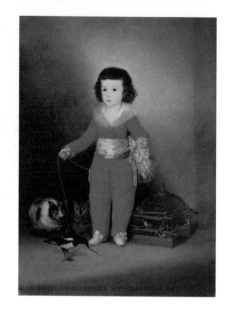

20___ _____

20___ _____ 20___ _____

_____ _____

_____ _____

_____ _____

20___ _____ 20___ _____

_____ _____

_____ _____

_____ _____

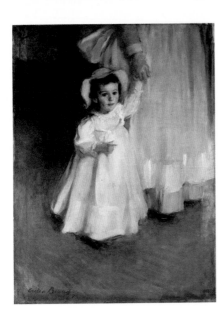

Ernesta
(Child with Nurse)
Cecilia Beaux,
American, 1855–1942

Maria DeWitt Jesup Fund,
1965 65.49

20 _ _ _____

20 _ _ _____ 20 _ _ _____

_____ _____

_____ _____

_____ _____

20 _ _ _____ 20 _ _ _____

_____ _____

_____ _____

_____ _____

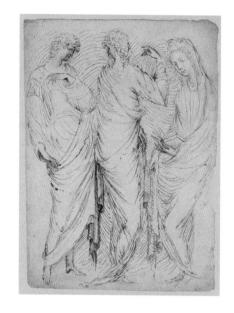

**Three Standing
Figures**

Stefano da Verona,
Italian, 1374/75–
ca. 1438

Harris Brisbane Dick Fund,
1996 1996.364a, b

20__ _____

20__ _____ 20__ _____

_____ _____

_____ _____

_____ _____

20__ _____ 20__ _____

_____ _____

_____ _____

_____ _____

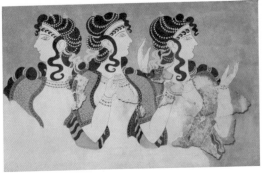

Reproduction of the "Ladies in Blue" fresco
Emile Gilliéron fils, 1927
Minoan, Late Minoan IB, ca. 1525–1450 B.C.
Dodge Fund, 1927 27.251

20_ _ _____

20_ _ _____ 20_ _ _____

_____ _____

_____ _____

_____ _____

20_ _ _____ 20_ _ _____

_____ _____

_____ _____

_____ _____

The Artist's Garden at St. Clair

Henri-Edmond Cross (Henri-Edmond Delacroix), French, 1856–1910

Harris Brisbane Dick Fund, 1948 48.10.7

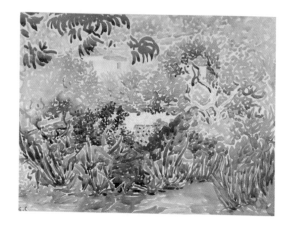

20＿＿ _____

20＿＿ _____ 20＿＿ _____

_____ _____

_____ _____

_____ _____

20＿＿ _____ 20＿＿ _____

_____ _____

_____ _____

_____ _____

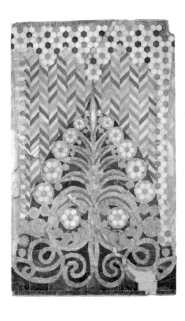

Mosaic Panel

**Louis Comfort
Tiffany,** American,
1848–1933

Tiffany Glass
Company, American,
1885–1892

Gift of Paul and Chloe
Nassau, 2000 2000.623

20＿＿ ———————————————

————————————————————

————————————————————

20＿＿ —————————— 20＿＿ ——————————

——————————— ———————————

——————————— ———————————

——————————— ———————————

20＿＿ —————————— 20＿＿ ——————————

——————————— ———————————

——————————— ———————————

——————————— ———————————

Velvet Textile for a Dragon Robe
Chinese, Qing dynasty (1644–1911)
Purchase, Friends of Asian Art Gifts, 1987 1987.147

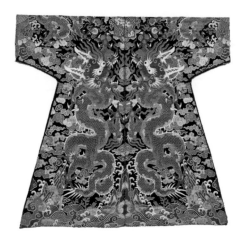

20__ _____

20__ _____ 20__ _____

_____ _____

_____ _____

_____ _____

20__ _____ 20__ _____

_____ _____

_____ _____

_____ _____

Fragment of a Tapestry or Wall Hanging
Swiss (Basel), ca. 1420–1430
The Cloisters Collection, 1990 1990.211

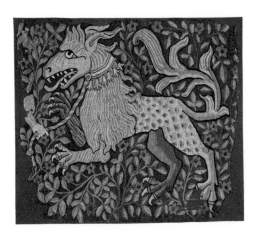

20___ _____

20___ _____ 20___ _____

20___ _____ 20___ _____

Railroad Bridge over the Marne at Joinville
Armand Guillaumin, French, 1841–1927
Robert Lehman Collection, 1975 1975.1.180

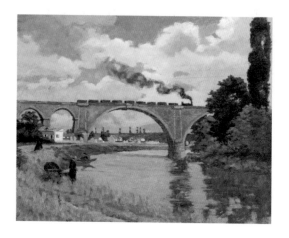

20__ _____

20__ _____

20__ _____

20__ _____

20__ _____

Le Pont Neuf

Hippolyte Petitjean,
French, 1854–1929

Robert Lehman Collection,
1975 1975.1.681

20_ _ _____

20_ _ _____ 20_ _ _____

_____ _____

_____ _____

_____ _____

20_ _ _____ 20_ _ _____

_____ _____

_____ _____

_____ _____

APRIL

5

**Standing Girl,
Back View**

Egon Schiele,
Austrian, 1890–1918

Bequest of Scofield Thayer,
1982 1984.433.296

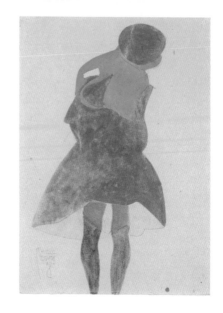

20__ _____

20__ _____ 20__ _____

_____ _____

_____ _____

_____ _____

20__ _____ 20__ _____

_____ _____

_____ _____

_____ _____

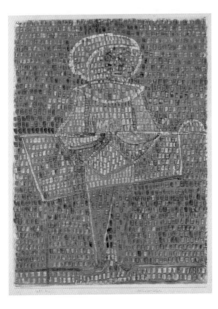

Boy in Fancy Dress

Paul Klee, German
(b. Switzerland),
1879–1940

The Berggruen Klee
Collection, 1988 1988.415

20＿＿ _____

20＿＿ _____ 20＿＿ _____

_____ _____

_____ _____

_____ _____

20＿＿ _____ 20＿＿ _____

_____ _____

_____ _____

_____ _____

Irises

Vincent van Gogh, Dutch, 1853–1890

Gift of Adele R. Levy, 1958 58.187

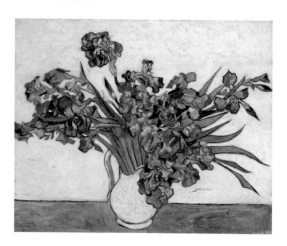

20_ _ _____

20_ _ _____ 20_ _ _____

20_ _ _____ 20_ _ _____

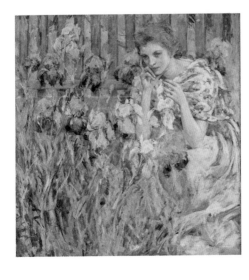

Fleur de Lis
Robert Reid,
American,
1862–1929

George A. Hearn
Fund, 1907 07.140

20__ _____

20__ _____ 20__ _____

_____ _____

_____ _____

_____ _____

20__ _____ 20__ _____

_____ _____

_____ _____

_____ _____

APRIL

9

Lilacs in a Window (Vase de Lilas a la Fenetre)

Mary Cassatt,
American,
1844–1926

Partial and Promised
Gift of Mr. and Mrs.
Douglas Dillon, 1997
1997.207

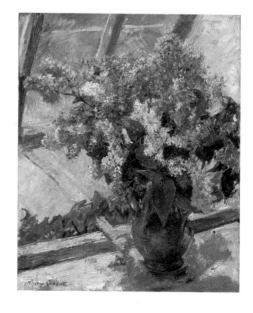

20__ _____

20__ _____ 20__ _____

_____ _____

_____ _____

_____ _____

20__ _____ 20__ _____

_____ _____

_____ _____

_____ _____

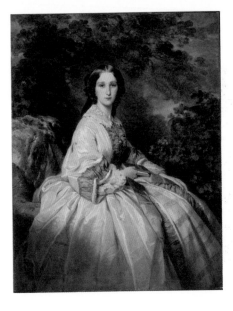

10

*Countess Alexander
Nikolaevitch
Lamsdorff (Maria
Ivanovna Beck,
1835–1866)*

**Franz Xaver
Winterhalter,**
German, 1805–1873

Bequest of Miss Adelaide
Milton de Groot (1876–1967),
1967 67.187.119

20__ _____

20__ _____ 20__ _____

_____ _____

_____ _____

_____ _____

20__ _____ 20__ _____

_____ _____

_____ _____

_____ _____

Still Life with Strawberries

French, 17th century

Bequest of Harry G. Sperling, 1971 1976.100.10

20__ _____

20__ _____ 20__ _____

_____ _____

_____ _____

_____ _____

20__ _____ 20__ _____

_____ _____

_____ _____

_____ _____

Still Life with Apples and a Pot of Primroses
Paul Cézanne, French, 1839–1906

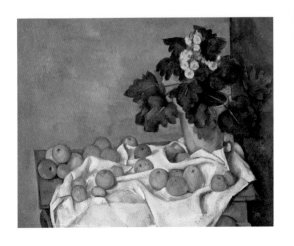

20_ _ _____

20_ _ _____ 20_ _ _____

_____ _____

_____ _____

_____ _____

20_ _ _____ 20_ _ _____

_____ _____

_____ _____

_____ _____

**Lily of the Valley
(Convallaria Majalis),**
from the *Flowers*
series for Old Judge
Cigarettes

Issued by Goodwin &
Company, American,
1890

George S. Harris &
Sons, American

The Jefferson R. Burdick
Collection, Gift of Jefferson R.
Burdick 63.350.214.164.37

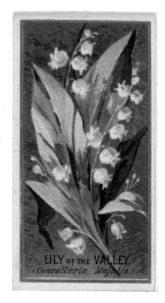

20___ _____

20___ _____ 20___ _____

_____ _____

_____ _____

_____ _____

20___ _____ 20___ _____

_____ _____

_____ _____

_____ _____

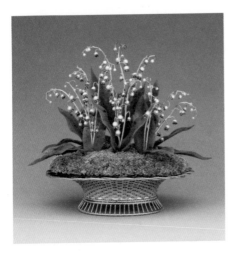

Imperial Lilies-of-the-Valley Basket

August Wilhelm Holmström, Russian, 1829–1903

House of Carl Fabergé

Matilda Geddings Gray Foundation L.2011.66.56a, b

20__ _____

20__ _____ 20__ _____

_____ _____

_____ _____

_____ _____

20__ _____ 20__ _____

_____ _____

_____ _____

_____ _____

Roses

Vincent van Gogh,
Dutch, 1853–1890

The Walter H. and
Leonore Annenberg
Collection, Gift of
Walter H. and Leonore
Annenberg, 1993,
Bequest of Walter H.
Annenberg, 2002
1993.400.5

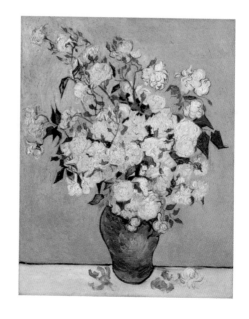

20__ _____

20__ _____

20__ _____

20__ _____

20__ _____

**_Yellow Roses and Bees, Pink
Roses and Wasps_**

Chinese, Qing dynasty
(1644–1911)

From the Collection of A. W. Bahr,
Purchase, Fletcher Fund, 1947 47.18.5

20__ _____

20__ _____ 20__ _____

_____ _____

_____ _____

_____ _____

20__ _____ 20__ _____

_____ _____

_____ _____

_____ _____

Vase

Louis Comfort Tiffany, American, 1848–1933

Tiffany Furnaces, American, 1902–1920

Gift of Louis Comfort Tiffany Foundation, 1951 51.121.22

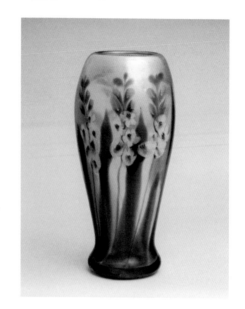

20__ _____

20__ _____ 20__ _____

_____ _____

_____ _____

_____ _____

20__ _____ 20__ _____

_____ _____

_____ _____

_____ _____

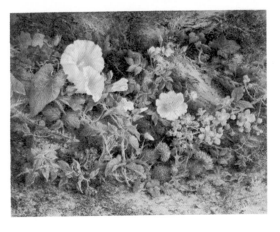

Flower Study
John Jessop Hardwick, British, 1831–1917

20_ _ _____

20_ _ _____ 20_ _ _____

_____ _____

_____ _____

_____ _____

20_ _ _____ 20_ _ _____

_____ _____

_____ _____

_____ _____

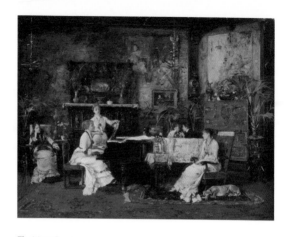

The Music Room

Mihály Munkácsy, Hungarian, 1844–1900

Bequest of Martha T. Fiske Collord, in memory of her first
husband, Josiah M. Fiske, 1908 08.136.11

20__ _____

20__ _____ 20__ _____

_____ _____

_____ _____

_____ _____

20__ _____ 20__ _____

_____ _____

_____ _____

_____ _____

APRIL

20

*Two Young Girls
at the Piano*

Auguste Renoir,
French, 1841–1919

Robert Lehman Collection,
1975 1975.1.201

20__ _____

20__ _____ 20__ _____

_____ _____

_____ _____

_____ _____

20__ _____ 20__ _____

_____ _____

_____ _____

_____ _____

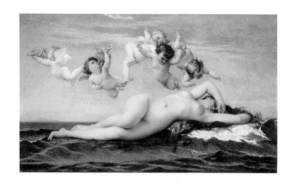

The Birth of Venus
Alexandre Cabanel, French, 1823–1889

Gift of John Wolfe, 1893 94.24.1

20_ _ _____

20_ _ _____ 20_ _ _____

_____ _____

_____ _____

_____ _____

20_ _ _____ 20_ _ _____

_____ _____

_____ _____

_____ _____

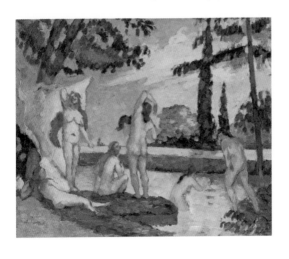

20_ _ _____

20_ _ _____ 20_ _ _____

_____ _____

_____ _____

_____ _____

20_ _ _____ 20_ _ _____

_____ _____

_____ _____

_____ _____

Mountain with Red House

Charles Demuth, American, 1883–1935

Alfred Stieglitz Collection, 1949 49.70.70a, b

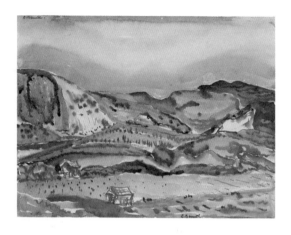

20__ _____

20__ _____ 20__ _____

_____ _____

_____ _____

_____ _____

20__ _____ 20__ _____

_____ _____

_____ _____

_____ _____

Hills around the Bay of Moulin Huet, Guernsey
Auguste Renoir, French, 1841–1919

Bequest of Julia W. Emmons, 1956 56.135.9

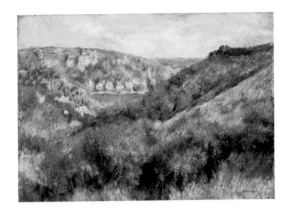

20__ _____

20__ _____ 20__ _____

_____ _____

_____ _____

_____ _____

20__ _____ 20__ _____

_____ _____

_____ _____

_____ _____

Allée of Chestnut Trees
Alfred Sisley, British, 1839–1899

Robert Lehman Collection, 1975 1975.1.211

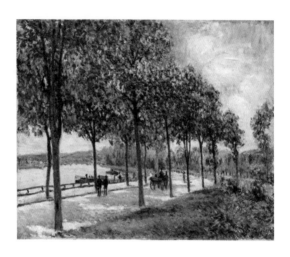

20_ _ _____

20_ _ _____ 20_ _ _____

_____ _____

_____ _____

_____ _____

20_ _ _____ 20_ _ _____

_____ _____

_____ _____

_____ _____

A Country Residence, Possibly General Moreau's
Country House at Morrisville, Pennsylvania

Pavel Petrovich Svinin, Russian, 1787/88–1839

Rogers Fund, 1942 42.95.49

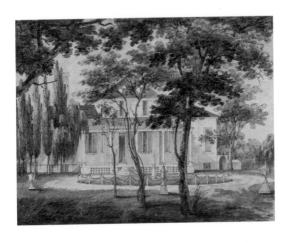

20_ _ _____

20_ _ _____ 20_ _ _____

_____ _____

_____ _____

_____ _____

20_ _ _____ 20_ _ _____

_____ _____

_____ _____

_____ _____

Scenes from the Life of Saint John the Baptist

Francesco Granacci (Francesco di Andrea di Marco),
Italian, 1469–1543

Purchase, Gwynne Andrews, Harris Brisbane Dick, Dodge, Fletcher, and
Rogers Funds, funds from various donors, Ella Morris de Peyster Gift,
Mrs. Donald Oenslager Gift, and Gifts in memory of Robert Lehman,
1970 1970.134.1

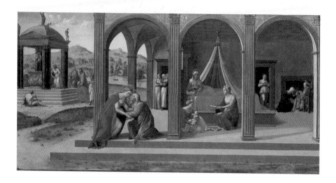

20__ _____

20__ _____ 20__ _____

_____ _____

_____ _____

20__ _____ 20__ _____

_____ _____

_____ _____

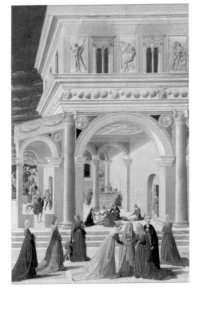

The Birth of the Virgin

**Fra Carnevale
(Bartolomeo di
Giovanni Corradini),**
Italian, born by
1416–1484

Rogers and Gwynne Andrews
Funds, 1935 35.121

20_ _ _____

20_ _ _____ 20_ _ _____

_____ _____

_____ _____

_____ _____

20_ _ _____ 20_ _ _____

_____ _____

_____ _____

_____ _____

Madonna and Child Enthroned with Saints

Raphael (Rafaello Sanzio or Santi), Italian, 1483–1520

Gift of J. Pierpont Morgan, 1916 16.30ab

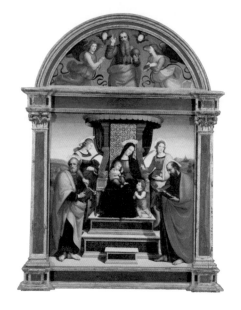

20__ _____

20__ _____ 20__ _____

_____ _____

_____ _____

_____ _____

20__ _____ 20__ _____

_____ _____

_____ _____

_____ _____

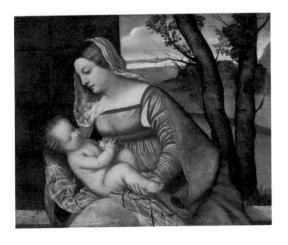

20_ _ _____

20_ _ _____ 20_ _ _____

_____ _____

_____ _____

_____ _____

20_ _ _____ 20_ _ _____

_____ _____

_____ _____

_____ _____

Oleanders

Vincent van Gogh, Dutch, 1853–1890

Gift of Mr. and Mrs. John L. Loeb, 1962 62.24

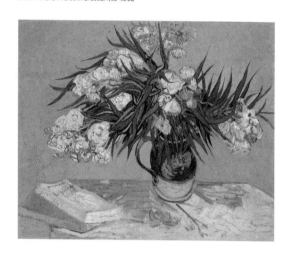

20__ _____

20__ _____ 20__ _____

_____ _____

_____ _____

_____ _____

20__ _____ 20__ _____

_____ _____

_____ _____

_____ _____

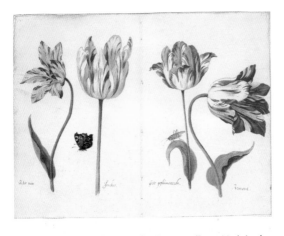

Four Tulips: Boter man (Butter Man), Joncker (Nobleman), Grote geplumaceerde (The Great Plumed One), and Voorwint (With the Wind)

Jacob Marrel, German, 1613/14–1681

Rogers Fund, 1968 68.66

20__ _____

20__ _____

20__ _____

20__ _____

20__ _____

Fan with Poetic Verses

Islamic, dated A.H. 1301/A.D.
1883–1884

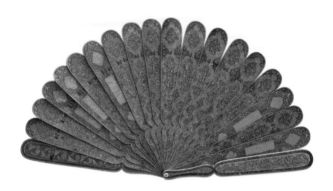

20_ _ _____

20_ _ _____ 20_ _ _____

_____ _____

_____ _____

_____ _____

20_ _ _____ 20_ _ _____

_____ _____

_____ _____

_____ _____

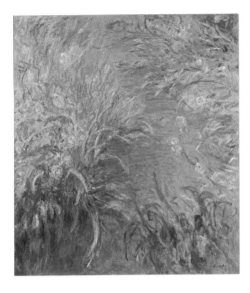

The Path through the Irises

Claude Monet,
French, 1840–1926

The Walter H. and
Leonore Annenberg
Collection, Gift of
Walter H. and Leonore
Annenberg, 2001,
Bequest of Walter H.
Annenberg, 2002
2001.202.6

20 _ _ _____

20 _ _ _____ 20 _ _ _____

_____ _____

_____ _____

_____ _____

20 _ _ _____ 20 _ _ _____

_____ _____

_____ _____

_____ _____

Repose
John White Alexander, American, 1856–1915

Anonymous Gift, 1980 1980.224

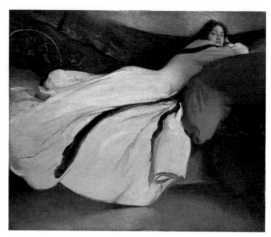

20__ _____

20__ _____ 20__ _____

_____ _____

_____ _____

_____ _____

20__ _____ 20__ _____

_____ _____

_____ _____

_____ _____

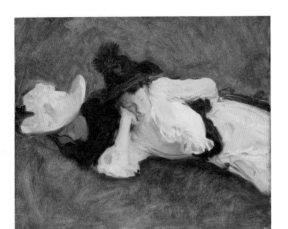

20 _ _ _____

20 _ _ _____

20 _ _ _____

20 _ _ _____

20 _ _ _____

MAY | 7

The Wyndham Sisters: Lady Elcho, Mrs. Adeane, and Mrs. Tennant

John Singer Sargent, American, 1856–1925

Catharine Lorillard Wolfe Collection, Wolfe Fund, 1927 27.67

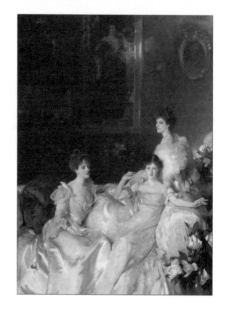

20_ _ _____

20_ _ _____ 20_ _ _____

_____ _____

_____ _____

_____ _____

20_ _ _____ 20_ _ _____

_____ _____

_____ _____

_____ _____

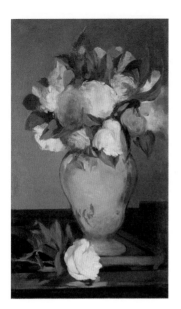

Peonies
Édouard Manet,
French, 1832–1883

Bequest of Joan Whitney
Payson, 1975 1976.201.16

MAY | 8

20_ _ _____

20_ _ _____ 20_ _ _____

20_ _ _____ 20_ _ _____

The Head of the Virgin in Three-Quarter View Facing Right

Leonardo da Vinci,
Italian, 1452–1519

Harris Brisbane Dick Fund, 1951 51.90

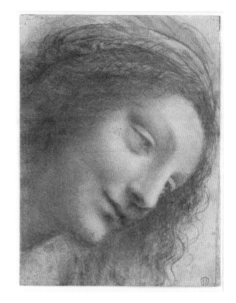

20＿＿ _____

20＿＿ _____

20＿＿ _____

20＿＿ _____

20＿＿ _____

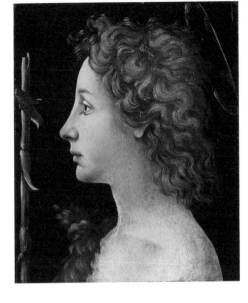

10

*The Young Saint
John the Baptist*

**Piero di Cosimo
(Piero di
Lorenzo di Piero
d'Antonio),** Italian,
1462–1522

The Bequest of Michael
Dreicer, 1921 22.60.52

20__ _____

20__ _____ 20__ _____

_____ _____

_____ _____

_____ _____

20__ _____ 20__ _____

_____ _____

_____ _____

_____ _____

Valley with Fir (Shade on the Mountain)

Henri-Edmond Cross (Henri-Edmond Delacroix),
French, 1856–1910

Robert Lehman Collection, 1975 1975.1.163

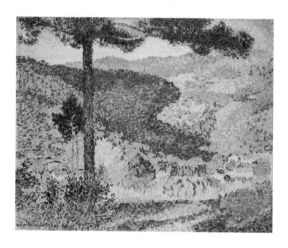

20_ _ _____

20_ _ _____ 20_ _ _____

_____ _____

_____ _____

_____ _____

20_ _ _____ 20_ _ _____

_____ _____

_____ _____

_____ _____

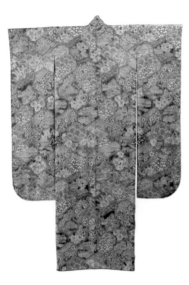

*Tokuseu Hitome
Sohshibori Hon
Furisode*

Takuo Itoh,
Japanese, b. 1947

Gift of Takuo Itoh, 1997
1997.228

20__ _____

20__ _____ 20__ _____
_____ _____
_____ _____
_____ _____

20__ _____ 20__ _____
_____ _____
_____ _____
_____ _____

MAY

13

Bouquet of Flowers

Odilon Redon,
French, 1840–1916

Gift of Mrs. George B.
Post, 1956 56.50

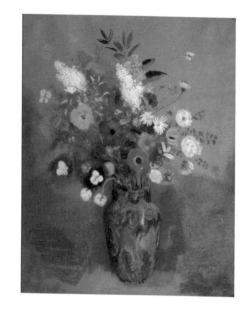

20__ _____

20__ _____ 20__ _____

_____ _____

_____ _____

_____ _____

20__ _____ 20__ _____

_____ _____

_____ _____

_____ _____

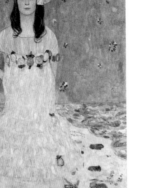

Mäda Primavesi
(1903–2000)

Gustav Klimt,
Austrian, 1862–1918

Gift of André and Clara
Mertens, in memory
of her mother, Jenny
Pulitzer Steiner, 1964
64.148

20_ _ _____

20_ _ _____ 20_ _ _____

_____ _____

_____ _____

_____ _____

20_ _ _____ 20_ _ _____

_____ _____

_____ _____

_____ _____

*Madame Philippe
Panon Desbassayns
de Richemont
(Jeanne Eglé
Mourgue, 1778–1855)
and Her Son,
Eugène (1800–1859)*

**Marie Guillelmine
Benoist,** French,
1768–1826

Gift of Julia A. Berwind,
1953 53.61.4

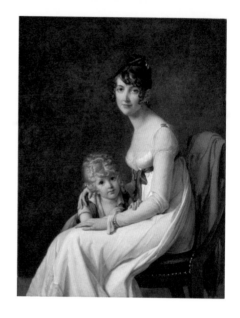

20_ _ _____

20_ _ _____ 20_ _ _____

_____ _____

_____ _____

20_ _ _____ 20_ _ _____

_____ _____

_____ _____

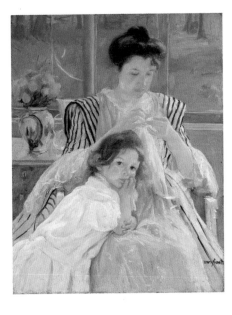

*Young Mother
Sewing*

Mary Cassatt,
American, 1844–1926

H. O. Havemeyer
Collection, Bequest of
Mrs. H. O. Havemeyer,
1929 29.100.48

20＿＿ ——————————————

——————————————————

——————————————————

20＿＿ —————————— 20＿＿ ——————————

—————————————— ——————————————

—————————————— ——————————————

—————————————— ——————————————

20＿＿ —————————— 20＿＿ ——————————

—————————————— ——————————————

—————————————— ——————————————

—————————————— ——————————————

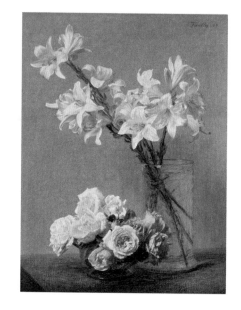

Roses and Lilies

Henri Fantin-Latour, French, 1836–1904

The Walter H. and Leonore Annenberg Collection, Gift of Walter H. and Leonore Annenberg, 2001, Bequest of Walter H. Annenberg, 2002 2001.202.4

20__ _____

20__ _____ 20__ _____

_____ _____

_____ _____

_____ _____

20__ _____ 20__ _____

_____ _____

_____ _____

_____ _____

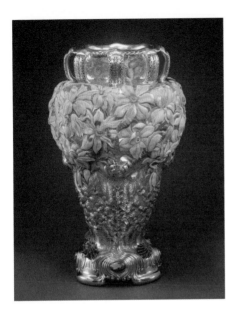

The Magnolia Vase

John T. Curran,
1859–1933

Manufactured
by Tiffany & Co.,
American,
1837–present

Gift of Mrs. Winthrop
Atwill, 1899 99.2

20＿＿ ＿＿＿＿＿＿＿＿＿＿＿＿＿＿＿＿＿
＿＿＿＿＿＿＿＿＿＿＿＿＿＿＿＿＿＿＿＿＿＿＿＿
＿＿＿＿＿＿＿＿＿＿＿＿＿＿＿＿＿＿＿＿＿＿＿＿

20＿＿ ＿＿＿＿＿＿＿＿＿＿ 20＿＿ ＿＿＿＿＿＿＿＿＿＿
＿＿＿＿＿＿＿＿＿＿＿＿＿＿＿＿ ＿＿＿＿＿＿＿＿＿＿＿＿＿＿＿＿
＿＿＿＿＿＿＿＿＿＿＿＿＿＿＿＿ ＿＿＿＿＿＿＿＿＿＿＿＿＿＿＿＿
＿＿＿＿＿＿＿＿＿＿＿＿＿＿＿＿ ＿＿＿＿＿＿＿＿＿＿＿＿＿＿＿＿

20＿＿ ＿＿＿＿＿＿＿＿＿＿ 20＿＿ ＿＿＿＿＿＿＿＿＿＿
＿＿＿＿＿＿＿＿＿＿＿＿＿＿＿＿ ＿＿＿＿＿＿＿＿＿＿＿＿＿＿＿＿
＿＿＿＿＿＿＿＿＿＿＿＿＿＿＿＿ ＿＿＿＿＿＿＿＿＿＿＿＿＿＿＿＿
＿＿＿＿＿＿＿＿＿＿＿＿＿＿＿＿ ＿＿＿＿＿＿＿＿＿＿＿＿＿＿＿＿

Cottage Garden,
Warwick, England

Edmund
Henry Garrett,
American,
1853–1929

Gift of Mr. and Mrs.
Stuart P. Feld, 1977
1977.426

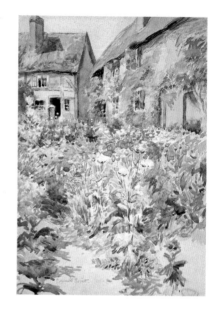

20__ __ _____

20__ __ _____ 20__ __ _____

20__ __ _____ 20__ __ _____

Garden at
Vaucresson
Édouard Vuillard,
French, 1868–1940

Catharine Lorillard Wolfe
Collection, Wolfe Fund,
1952 52.183

20__ _____

20__ _____ 20__ _____

_____ _____

_____ _____

_____ _____

20__ _____ 20__ _____

_____ _____

_____ _____

_____ _____

*Bridge over
a Pond of
Water Lilies*

Claude Monet,
French, 1840–1926

H. O. Havemeyer
Collection, Bequest of
Mrs. H. O. Havemeyer,
1929 29.100.113

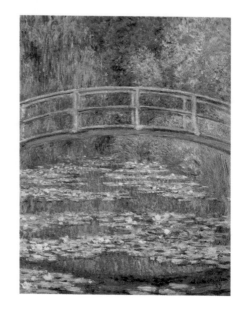

20＿＿ _____

20＿＿ _____ 20＿＿ _____

_____ _____

_____ _____

_____ _____

20＿＿ _____ 20＿＿ _____

_____ _____

_____ _____

_____ _____

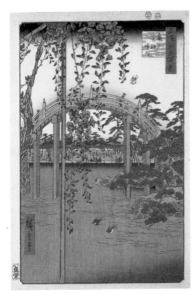

*In the Kameido
Tenjin Shrine
Compound*

Utagawa Hiroshige,
Japanese, 1797–1858

The Howard Mansfield
Collection, Purchase,
Rogers Fund, 1936 JP2517

20_ _ _____

20_ _ _____ 20_ _ _____

_____ _____

_____ _____

20_ _ _____ 20_ _ _____

_____ _____

_____ _____

MAY | 23

Diana

Augustus Saint-Gaudens, American, 1848–1907

Rogers Fund, 1928
28.101

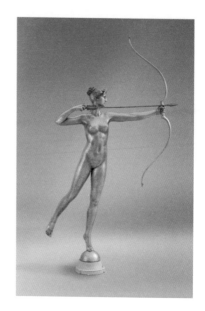

20_ _ _____

20_ _ _____ 20_ _ _____

_____ _____

_____ _____

_____ _____

20_ _ _____ 20_ _ _____

_____ _____

_____ _____

_____ _____

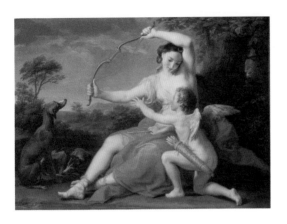

Diana and Cupid
Pompeo Batoni, Italian, 1708–1787

Purchase, The Charles Engelhard Foundation, Robert Lehman Foundation Inc., Mrs. Haebler Frantz, April R. Axton, L. H. P. Klotz, and David Mortimer Gifts; and Gifts of Mr. and Mrs. Charles Wrightsman, George Blumenthal, and J. Pierpont Morgan, Bequests of Millie Bruhl Fredrick and Mary Clark Thompson, and Rogers Fund, by exchange, 1982 1982.438

20__ _____

20__ _____ 20__ _____

_____ _____

_____ _____

_____ _____

20__ _____ 20__ _____

_____ _____

_____ _____

_____ _____

*Portrait of a
Woman*

Egon Schiele,
Austrian, 1890–1918

Museum Accession,
transferred from the
Library WW.288

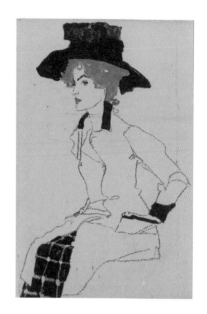

20__ _____

20__ _____ 20__ _____

_____ _____

_____ _____

_____ _____

20__ _____ 20__ _____

_____ _____

_____ _____

_____ _____

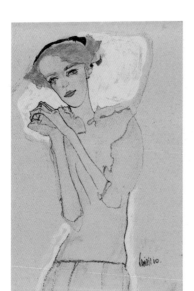

Portrait of a Woman

Egon Schiele,
Austrian, 1890–1918

Museum Accession,
transferred from the
Library WW.289

MAY

26

20__ _____

20__ _____ 20__ _____
_____ _____
_____ _____
_____ _____

20__ _____ 20__ _____
_____ _____
_____ _____
_____ _____

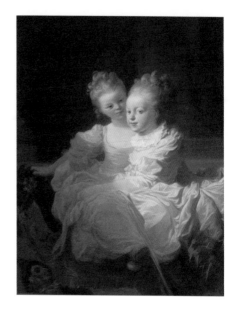

The Two Sisters

Jean Honoré Fragonard,
French, 1732–1806

Gift of Julia A. Berwind,
1953 53.61.5

20__ _____

20__ _____ 20__ _____

_____ _____

_____ _____

_____ _____

20__ _____ 20__ _____

_____ _____

_____ _____

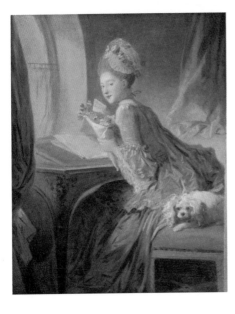

The Love Letter
Jean Honoré Fragonard, French, 1732–1806

The Jules Bache Collection, 1949 49.7.49

20__ _____

20__ _____ 20__ _____

_____ _____

_____ _____

_____ _____

20__ _____ 20__ _____

_____ _____

_____ _____

_____ _____

Teapot

Sèvres Manufactory,
French, 1740–
present

Purchase, Louis V. Bell
Fund and Friends of
European Sculpture and
Decorative Arts Gifts,
2007 2007.408a, b

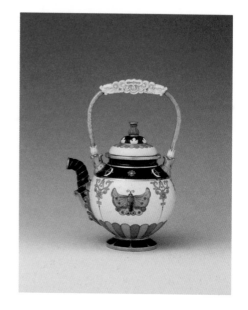

20__ _____

20__ _____ 20__ _____

_____ _____

_____ _____

20__ _____ 20__ _____

_____ _____

_____ _____

*The Oiran Yoso-oi
Seated at Her Toilet*

Kitagawa Utamaro,
Japanese, 1753?–1806

Purchase, Joseph Pulitzer
Bequest, 1918 JP556

20_ _ _____

20_ _ _____ 20_ _ _____

_____ _____

_____ _____

_____ _____

20_ _ _____ 20_ _ _____

_____ _____

_____ _____

_____ _____

"The Emperor Shah Jahan with his Son Dara Shikoh", Folio from the *Shah Jahan Album*

Nanha (painter), Islamic

Mir 'Ali Haravi (calligrapher), Islamic, d. ca. 1550

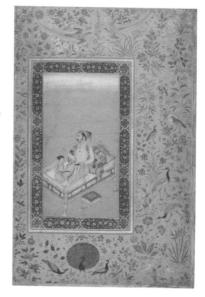

20_ _ _____

20_ _ _____ 20_ _ _____

20_ _ _____ 20_ _ _____

20_ _ ———————————————————

————————————————————————

————————————————————————

20_ _ ——————————— 20_ _ ———————————

———————————————— ————————————————

———————————————— ————————————————

———————————————— ————————————————

20_ _ ——————————— 20_ _ ———————————

———————————————— ————————————————

———————————————— ————————————————

———————————————— ————————————————

Grapevine Panel

Louis Comfort Tiffany,
American, 1848–1933

Tiffany Studios,
American, 1902–1932

Gift of Ruth and Frank
Stanton, 1978 1978.19.2

20_ _ _____

20_ _ _____ 20_ _ _____

_____ _____

_____ _____

_____ _____

20_ _ _____ 20_ _ _____

_____ _____

_____ _____

_____ _____

Tennis at Newport
George Bellows,
American, 1882–1925

Bequest of Miss Adelaide
Milton de Groot
(1876–1967), 1967 67.187.121

20__ _____

20__ _____ 20__ _____

_____ _____

_____ _____

_____ _____

20__ _____ 20__ _____

_____ _____

_____ _____

_____ _____

**Young Girl in a
Blue Dress**

Auguste Renoir,
French, 1841–1919

Robert Lehman
Collection, 1975
1975.1.688

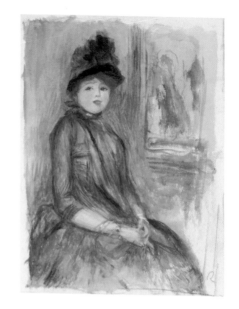

20__ _____

20__ _____ 20__ _____

_____ _____

_____ _____

_____ _____

20__ _____ 20__ _____

_____ _____

_____ _____

_____ _____

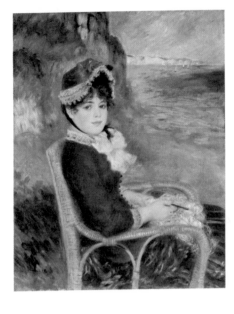

By the Seashore

Auguste Renoir,
French, 1841–1919

H. O. Havemeyer
Collection, Bequest of
Mrs. H. O. Havemeyer,
1929 29.100.125

20__ _____

20__ _____ 20__ _____

_____ _____

_____ _____

20__ _____ 20__ _____

_____ _____

_____ _____

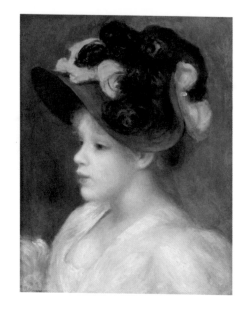

*Young Girl in a
Pink-and-Black Hat*

Auguste Renoir,
French, 1841–1919

Gift of Kathryn B. Miller,
1964 64.150

20__ _____

20__ _____ 20__ _____

_____ _____

_____ _____

_____ _____

20__ _____ 20__ _____

_____ _____

_____ _____

_____ _____

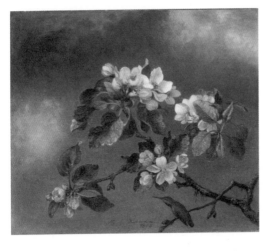

Hummingbird and Apple Blossoms

Martin Johnson Heade, American, 1819–1904

Gift of Mrs. J. Augustus Barnard, 1979 1979.490.11

20__ _____

20__ _____ 20__ _____

_____ _____

_____ _____

_____ _____

20__ _____ 20__ _____

_____ _____

_____ _____

_____ _____

Basket of Flowers
Eugène Delacroix, French, 1798–1863

Bequest of Miss Adelaide Milton de Groot (1876–1967), 1967 67.187.60

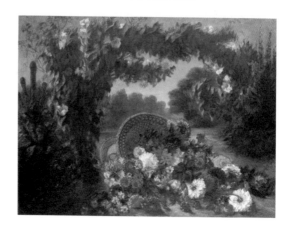

20_ _ _____

20_ _ _____ 20_ _ _____

_____ _____

_____ _____

_____ _____

20_ _ _____ 20_ _ _____

_____ _____

_____ _____

_____ _____

Victorian Interior II

Horace Pippin, American, 1888–1946

Arthur Hoppock Hearn Fund, 1958 58.26

20__ _____

20__ _____

20__ _____

20__ _____

20__ _____

JUNE

10

Black Columns in a Landscape
Paul Klee, German (b. Switzerland), 1879–1940

The Berggruen Klee Collection, 1987 1987.455.1

20___ _____

20___ _____ 20___ _____

_____ _____

_____ _____

20___ _____ 20___ _____

_____ _____

_____ _____

Garden Landscape

Louis Comfort Tiffany, American, 1848–1933

Tiffany Studios, American, 1902–1932

Gift of Lillian Nassau, 1976 1976.105

20＿＿ _____

20＿＿ _____ 20＿＿ _____

_____ _____

_____ _____

_____ _____

20＿＿ _____ 20＿＿ _____

_____ _____

_____ _____

_____ _____

Water Lilies

Claude Monet, French,
1840–1926

The Walter H. and Leonore
Annenberg Collection, Gift of
Walter H. and Leonore Annenberg,
1998, Bequest of Walter H.
Annenberg, 2002 1998.325.2

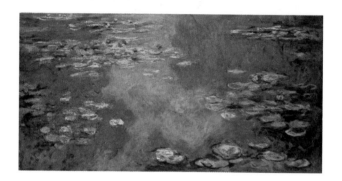

20_ _ _____

20_ _ _____ 20_ _ _____

_____ _____

_____ _____

20_ _ _____ 20_ _ _____

_____ _____

_____ _____

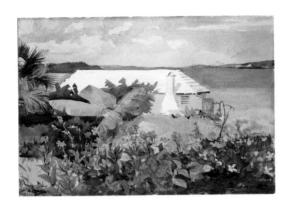

*Flower Garden and
Bungalow, Bermuda*

Winslow Homer,
American, 1836–1910

Amelia B. Lazarus Fund,
1910 10.228.10

20__ _____

20__ _____ 20__ _____

_____ _____

_____ _____

_____ _____

20__ _____ 20__ _____

_____ _____

_____ _____

_____ _____

Incense Burner in the Shape of a Rooster

Japanese, Edo Period
(1615–1868)

Purchase, Friends of Asian Art
Gifts, 1993 1993.193a–c

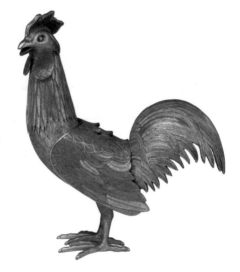

20__ _____

20__ _____ 20__ _____

20__ _____ 20__ _____

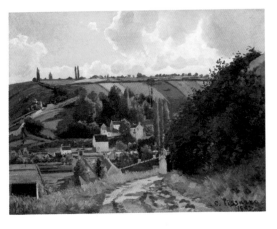

Jalais Hill, Pontoise
Camille Pissarro, French, 1830–1903
Bequest of William Church Osborn, 1951 51.30.2

20__ _____

20__ _____ 20__ _____
_____ _____
_____ _____
_____ _____

20__ _____ 20__ _____
_____ _____
_____ _____
_____ _____

JUNE

16

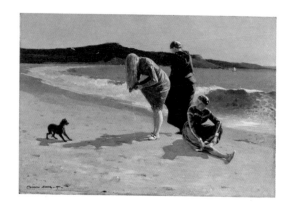

Eagle Head, Manchester, Massachusetts (High Tide)
Winslow Homer, American, 1836–1910

Gift of Mrs. William F. Milton, 1923 23.77.2

20__ _____

20__ _____ 20__ _____

_____ _____

_____ _____

_____ _____

20__ _____ 20__ _____

_____ _____

_____ _____

_____ _____

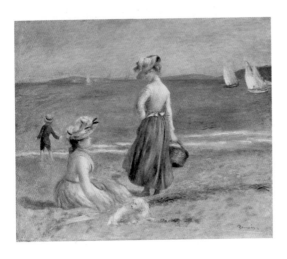

20_ _ _____

20_ _ _____ 20_ _ _____

_____ _____

_____ _____

_____ _____

20_ _ _____ 20_ _ _____

_____ _____

_____ _____

_____ _____

Joséphine-Éléonore-Marie-Pauline de Galard de Brassac de Béarn (1825–1860), Princesse de Broglie

Jean Auguste Dominique Ingres, French, 1780–1867

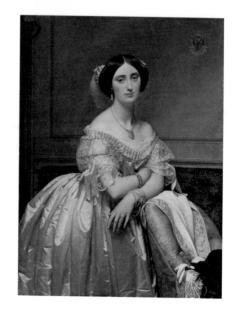

20__ _____

20__ _____

20__ _____

20__ _____

20__ _____

Egyptian (Middle Kingdom), first half of Dynasty 12,
reign of Senwosret I to Senwosret II, ca. 1961–1878 B.C.

Gift of Edward S. Harkness 1917 17.9.1

20___ _____

20___ _____ 20___ _____

_____ _____

_____ _____

_____ _____

20___ _____ 20___ _____

_____ _____

_____ _____

_____ _____

Boating

Édouard Manet, French, 1832–1883

H. O. Havemeyer Collection, Bequest of Mrs. H. O.
Havemeyer, 1929 29.100.115

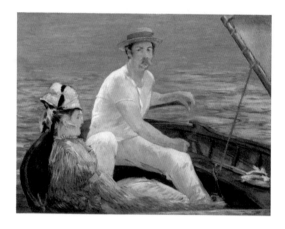

20＿＿ _____

20＿＿ _____

20＿＿ _____

20＿＿ _____

20＿＿ _____

Camille Monet (1847–1879) on a Garden Bench

Claude Monet, French, 1840–1926

The Walter H. and Leonore Annenberg Collection, Gift of Walter H. and Leonore
Annenberg, 2002, Bequest of Walter H. Annenberg, 2002 2002.62.1

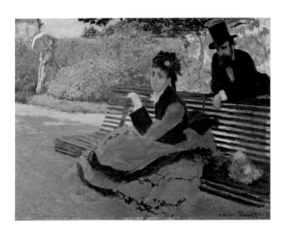

20__ _____

20__ _____ 20__ _____

_____ _____

_____ _____

_____ _____

20__ _____ 20__ _____

_____ _____

_____ _____

_____ _____

Crowd at the Seashore
William James Glackens, American, 1870–1938

Bequest of Miss Adelaide Milton de Groot (1876–1967), 1967 67.187.126

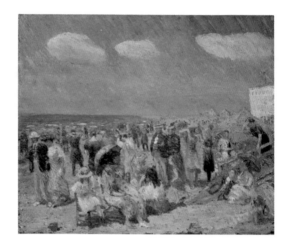

20_ _ _____

20_ _ _____ 20_ _ _____

_____ _____

_____ _____

_____ _____

20_ _ _____ 20_ _ _____

_____ _____

_____ _____

_____ _____

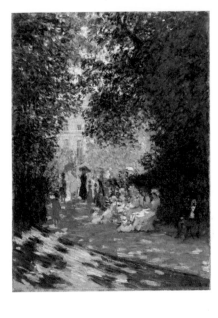

JUNE

23

The Parc Monceau
Claude Monet,
French, 1840–1926

The Mr. and Mrs. Henry
Ittleson Jr. Purchase
Fund, 1959 59.142

20__ _____

20__ _____ 20__ _____

_____ _____

_____ _____

_____ _____

20__ _____ 20__ _____

_____ _____

_____ _____

_____ _____

Krishna Holds up Mount Govardhan to Shelter the Villagers of Braj

Folio from a *Harivamsa*
*(The Legend of Hari
[Krishna])*

Pakistani (probably
Lahore), ca. 1590–1595

Purchase, Edward C. Moore Jr.
Gift, 1928 28.63.1

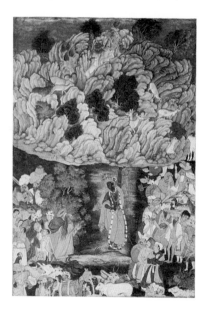

20__ _____

20__ _____ 20__ _____

_____ _____

_____ _____

_____ _____

20__ _____ 20__ _____

_____ _____

_____ _____

_____ _____

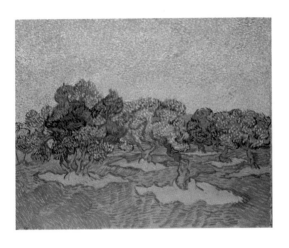

Olive Trees

Vincent van Gogh, Dutch, 1853–1890

The Walter H. and Leonore Annenberg Collection, Gift of Walter H. and
Leonore Annenberg, 1998, Bequest of Walter H. Annenberg, 2002 1998.325.1

J U N E

25

20＿＿ _____

20＿＿ _____ 20＿＿ _____

_____ _____

_____ _____

_____ _____

20＿＿ _____ 20＿＿ _____

_____ _____

_____ _____

_____ _____

In Full Sunlight (En plein soleil)
James Tissot, French, 1836–1902

Gift of Mrs. Charles Wrightsman, 2006 2006.278

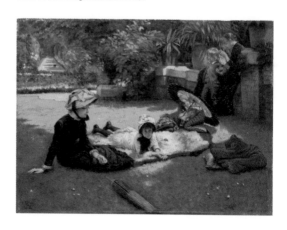

20__ _____

20__ _____

20__ _____

20__ _____

20__ _____

20__ _____

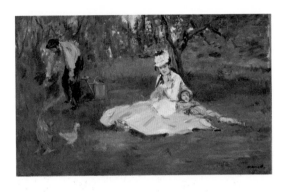

The Monet Family in Their Garden at Argenteuil
Édouard Manet, French, 1832–1883

Bequest of Joan Whitney Payson, 1975 1976.201.14

JUNE | 27

20__ _____

20__ _____ 20__ _____

20__ _____ 20__ _____

JUNE | 28

The Love Song
Sir Edward Burne-Jones, British, 1833–1898

The Alfred N. Punnett Endowment Fund, 1947 47.26

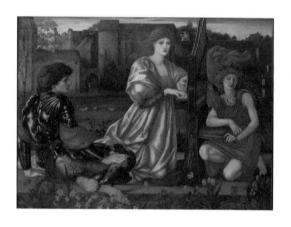

20_ _ _____

20_ _ _____ 20_ _ _____

_____ _____

_____ _____

_____ _____

20_ _ _____ 20_ _ _____

_____ _____

_____ _____

_____ _____

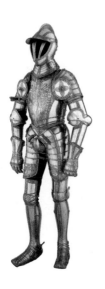

***Armor of Emperor
Ferdinand I
(1503–1564)***

Kunz Lochner,
German, 1510–1567

Purchase, Rogers Fund
and George D. Pratt Gift,
1933 33.164a–x

JUNE

29

20__ _____

20__ _____ 20__ _____

_____ _____

_____ _____

_____ _____

20__ _____ 20__ _____

_____ _____

_____ _____

_____ _____

Still Life with Pansies
Henri Fantin-Latour, French, 1836–1904

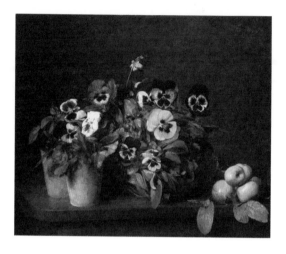

20__ _____

20__ _____ 20__ _____

20__ _____ 20__ _____

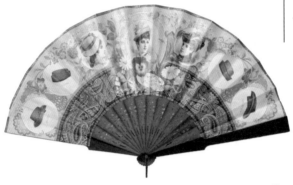

Fan

Donaldson Brothers, American, 1880

20＿＿ _____

20＿＿ _____ 20＿＿ _____

_____ _____

_____ _____

_____ _____

20＿＿ _____ 20＿＿ _____

_____ _____

_____ _____

_____ _____

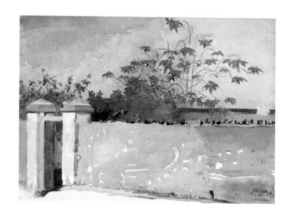

A Wall, Nassau

Winslow Homer, American, 1836–1910

Amelia B. Lazarus Fund, 1910 10.228.9

20__ _____

20__ _____ 20__ _____

_____ _____

_____ _____

20__ _____ 20__ _____

_____ _____

_____ _____

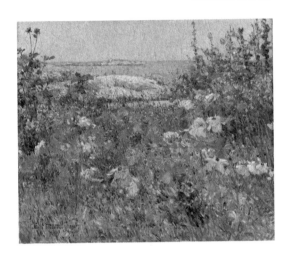

20_ _ _____

20_ _ _____ 20_ _ _____

_____ _____

_____ _____

_____ _____

20_ _ _____ 20_ _ _____

_____ _____

_____ _____

_____ _____

Side Drum

**Attributed to
Ernest Vogt,**
American, ca. 1864

The Crosby Brown
Collection of Musical
Instruments, 1889
89.4.2162

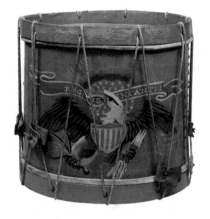

20_ _ _____

20_ _ _____ 20_ _ _____

_____ _____

_____ _____

_____ _____

20_ _ _____ 20_ _ _____

_____ _____

_____ _____

_____ _____

*Washington Crossing
the Delaware*

Emanuel Leutze,
American
(b. Germany), 1816–1868

Gift of John Stewart Kennedy,
1897 97.34

JULY

5

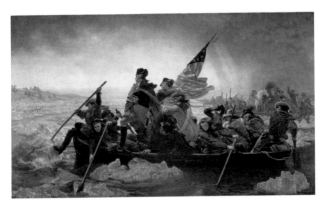

20 _ _ _____

20 _ _ _____ 20 _ _ _____

20 _ _ _____ 20 _ _ _____

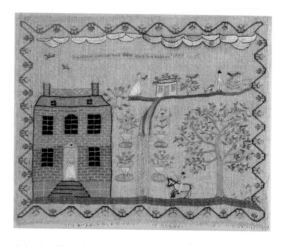

Embroidered Sampler
Millsent Connor, American, b. 1789
Gift of Edgar William and Bernice Chrysler Garbisch, 1974 1974.42

20__ _____

20__ _____ 20__ _____

_____ _____

_____ _____

_____ _____

20__ _____ 20__ _____

_____ _____

_____ _____

_____ _____

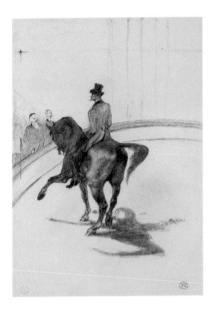

At the Circus:
The Spanish Walk
(Au Cirque: le Pas
espagnol)

Henri de Toulouse-
Lautrec, French,
1864–1901

Robert Lehman Collection,
1975 1975.1.731

20__ _____

20__ _____ 20__ _____

20__ _____ 20__ _____

*Vase of Flowers
(Pink Background)*

Odilon Redon,
French, 1840–1916

Bequest of Mabel Choate,
in memory of her father,
Joseph Hodges Choate,
1958 59.16.3

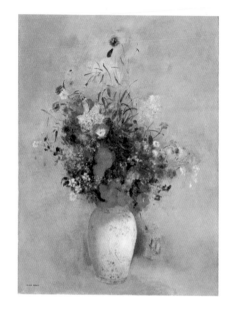

20_ _ _____

20_ _ _____ 20_ _ _____

_____ _____

_____ _____

_____ _____

20_ _ _____ 20_ _ _____

_____ _____

_____ _____

_____ _____

Bottle

Bohemian
(Czech Republic),
1700–1800

Gift of Frederick W.
Hunter, 1913. 13.179.41

20_ _ _____

20_ _ _____ 20_ _ _____

_____ _____

_____ _____

_____ _____

20_ _ _____ 20_ _ _____

_____ _____

_____ _____

_____ _____

*Bouquet of
Sunflowers*

Claude Monet,
French, 1840–1926

H. O. Havemeyer
Collection, Bequest of
Mrs. H. O. Havemeyer,
1929 29.100.107

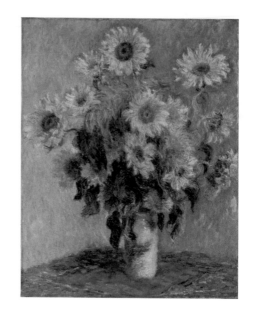

20__ _____

20__ _____ 20__ _____

_____ _____

_____ _____

_____ _____

20__ _____ 20__ _____

_____ _____

_____ _____

_____ _____

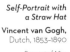

Self-Portrait with
a Straw Hat

Vincent van Gogh,
Dutch, 1853–1890

Bequest of Miss
Adelaide Milton de
Groot (1876–1967), 1967
67.187.70a

20_ _ _____

20_ _ _____ 20_ _ _____

_____ _____

_____ _____

_____ _____

20_ _ _____ 20_ _ _____

_____ _____

_____ _____

_____ _____

Still Life with Apples and Pitcher

Camille Pissarro, French, 1830-1903

Purchase, Mr. and Mrs. Richard J. Bernhard Gift, by exchange, 1983 1983.166

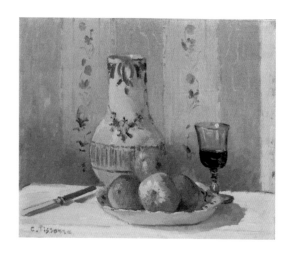

20_ _ _____

20_ _ _____ 20_ _ _____

_____ _____

_____ _____

_____ _____

20_ _ _____ 20_ _ _____

_____ _____

_____ _____

_____ _____

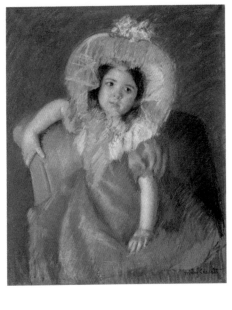

*Margot in
Orange Dress*

Mary Cassatt,
American,
1844–1926

From the Collection of
James Stillman, Gift of
Dr. Ernest G. Stillman,
1922 22.16.25

20_ _ _____

20_ _ _____ 20_ _ _____

_____ _____

_____ _____

_____ _____

20_ _ _____ 20_ _ _____

_____ _____

_____ _____

_____ _____

Scherzo di Follia

Pierre-Louis Pierson, French, 1822–1913

Gilman Collection, Gift of The Howard Gilman Foundation, 2005
2005.100.198

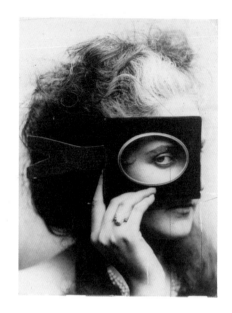

20_ _ _____

20_ _ _____ 20_ _ _____

_____ _____

_____ _____

_____ _____

20_ _ _____ 20_ _ _____

_____ _____

_____ _____

_____ _____

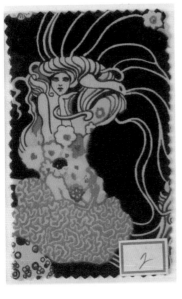

Textile sample
Gustav Klimt,
Austrian, 1862–1918

Gift of Joanne F. du Pont
and John F. Pleasants,
in memory of Enos
Rogers Pleasants, III, 1984
1984.537.37a–f

JULY

15

20__ _____

20__ _____ 20__ _____

_____ _____

_____ _____

_____ _____

20__ _____ 20__ _____

_____ _____

_____ _____

_____ _____

*Mrs. Walter
Rathbone Bacon
(Virginia Purdy
Barker, 1862–1919)*

Anders Zorn,
Swedish, 1860–1920

Gift of Mrs. Walter
Rathbone Bacon, in
memory of her husband,
1917 17.204

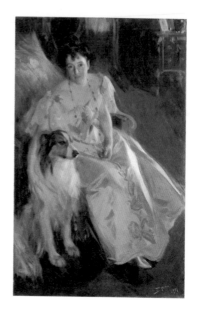

20__ _____

20__ _____ 20__ _____

20__ _____ 20__ _____

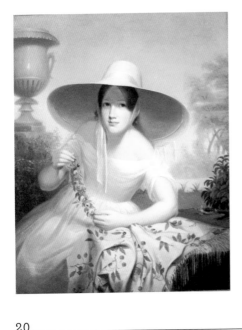

Spring

**Cephas Giovanni
Thompson,**
American,
1809–1888

Gift of Mrs. Madeleine
Thompson Edmonds, 1971
1971.244

20__ _____

20__ _____ 20__ _____

_____ _____

_____ _____

20__ _____ 20__ _____

_____ _____

_____ _____

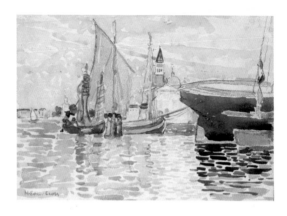

Venice-The Giudecca
Henri-Edmond Cross (Henri-Edmond Delacroix), French, 1856–1910

Robert Lehman Collection, 1975 1975.1.594

20_ _ _____

20_ _ _____ 20_ _ _____

_____ _____

_____ _____

_____ _____

20_ _ _____ 20_ _ _____

_____ _____

_____ _____

_____ _____

At the Seaside
William Merritt Chase,
American, 1849–1916

Bequest of Miss Adelaide Milton
de Groot (1876–1967), 1967 67.187.123

JULY

19

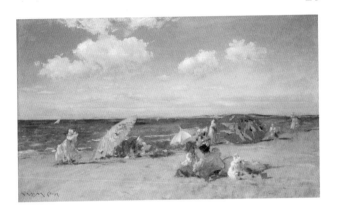

20_ _ _____

20_ _ _____ 20_ _ _____

_____ _____

_____ _____

_____ _____

20_ _ _____ 20_ _ _____

_____ _____

_____ _____

_____ _____

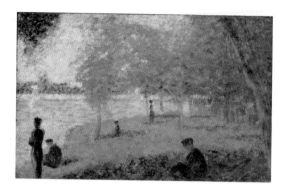

Study for "A Sunday on La Grande Jatte"
Georges Seurat, French, 1859–1891

Robert Lehman Collection, 1975 1975.1.207

20_ _ _____

20_ _ _____ 20_ _ _____

_____ _____

_____ _____

20_ _ _____ 20_ _ _____

_____ _____

_____ _____

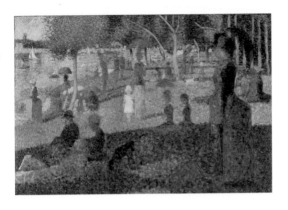

Study for "A Sunday on La Grande Jatte"
Georges Seurat, French, 1859–1891
Bequest of Sam A. Lewisohn, 1951 51.112.6

20__ _____

20__ _____ 20__ _____

_____ _____

_____ _____

20__ _____ 20__ _____

_____ _____

_____ _____

_____ _____

*The Banks of
the Bièvre near
Bicêtre*

**Henri Rousseau
(le Douanier),**
French, 1844–1910

Gift of Marshall Field,
1939 39.15

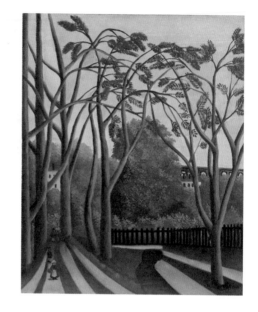

20__ _____

20__ _____ 20__ _____

_____ _____

_____ _____

_____ _____

20__ _____ 20__ _____

_____ _____

_____ _____

_____ _____

Trees and Houses Near the Jas de Bouffan
Paul Cézanne, French, 1839–1906
Robert Lehman Collection, 1975 1975.1.160

JULY

23

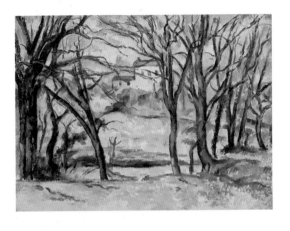

20__ _____

20__ _____ 20__ _____

_____ _____

_____ _____

_____ _____

20__ _____ 20__ _____

_____ _____

_____ _____

_____ _____

Hibiscus and Parrots

Louis Comfort Tiffany, American, 1848–1933

Tiffany Studios, American, 1902–32

Gift of Earl and Lucille Sydnor, 1990 1990.315

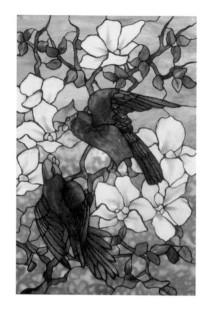

20_ _ _____

20_ _ _____ 20_ _ _____

_____ _____

_____ _____

_____ _____

20_ _ _____ 20_ _ _____

_____ _____

_____ _____

_____ _____

25

The Concourse of the Birds

Folio 11r from a *Mantiq al-tair (Language of the Birds)*

Painter Habiballah of Sava, Iranian, active ca. 1590–1610

Fletcher Fund, 1963 63.210.11

20__ _____

20__ _____ 20__ _____

_____ _____

_____ _____

_____ _____

20__ _____ 20__ _____

_____ _____

_____ _____

_____ _____

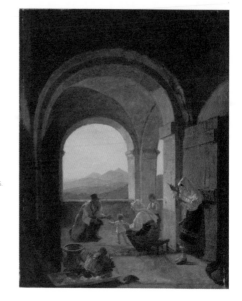

First Steps

Franz Ludwig Catel,
German, 1778–1856

The Whitney Collection,
Promised Gift of Wheelock
Whitney III, and Purchase,
Gift of Mr. and Mrs. Charles S.
McVeigh, by exchange,
2003 2003.42.9

20_ _ _____

20_ _ _____ 20_ _ _____

_____ _____

_____ _____

20_ _ _____ 20_ _ _____

_____ _____

_____ _____

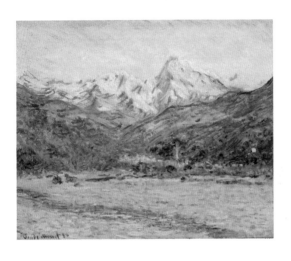

20_ _ _____

20_ _ _____ 20_ _ _____

_____ _____

_____ _____

_____ _____

20_ _ _____ 20_ _ _____

_____ _____

_____ _____

_____ _____

Stage Fort across Gloucester Harbor

Fitz Henry Lane (formerly Fitz Hugh Lane),
American, 1804–1865

Purchase, Rogers and Fletcher Funds, Erving and Joyce Wolf Fund,
Raymond J. Horowitz Gift, Bequest of Richard De Wolfe Brixey, by
exchange, and John Osgood and Elizabeth Amis Cameron Blanchard
Memorial Fund, 1978 1978.203

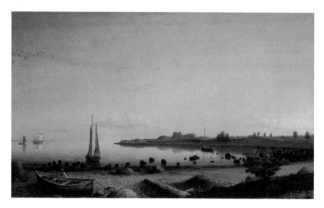

20___ _____

20___ _____ 20___ _____

_____ _____

_____ _____

_____ _____

20___ _____ 20___ _____

_____ _____

_____ _____

_____ _____

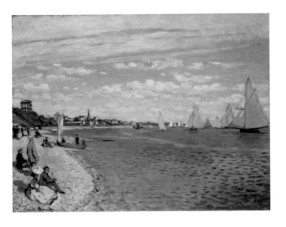

Regatta at Sainte-Adresse
Claude Monet, French, 1840–1926
Bequest of William Church Osborn, 1951 51.30.4

20__ _____

20__ _____ 20__ _____

_____ _____

_____ _____

_____ _____

20__ _____ 20__ _____

_____ _____

_____ _____

_____ _____

John Biglin in a Single Scull
Thomas Eakins, American, 1844–1916

Fletcher Fund, 1924 24.108

20__ _____

20__ _____ 20__ _____

_____ _____

_____ _____

_____ _____

20__ _____ 20__ _____

_____ _____

_____ _____

_____ _____

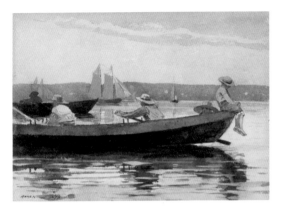

Boys in a Dory
Winslow Homer, American, 1836–1910

Bequest of Molly Flagg Knudtsen, 2001 2001.608.1

20_ _ _____

20_ _ _____ 20_ _ _____

20_ _ _____ 20_ _ _____

Surf, Isles of Shoals
Childe Hassam, American, 1859–1935

Gift of Dr. and Mrs. Sheldon C. Sommers, 1996 1996.382

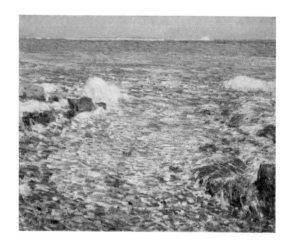

20_ _ _____

20_ _ _____ 20_ _ _____

_____ _____

_____ _____

_____ _____

20_ _ _____ 20_ _ _____

_____ _____

_____ _____

_____ _____

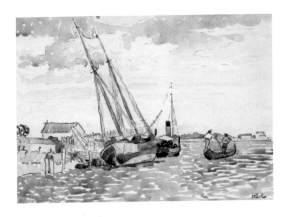

Marine Scene (Boats near Venice)

Henri-Edmond Cross (Henri-Edmond Delacroix) French, 1856–1910

Robert Lehman Collection, 1975 1975.1.593

20__ _____

20__ _____ 20__ _____

_____ _____

_____ _____

_____ _____

20__ _____ 20__ _____

_____ _____

_____ _____

_____ _____

Wheat Field with Cypresses
Vincent van Gogh, Dutch, 1853–1890

Purchase, The Annenberg Foundation Gift, 1993 1993.132

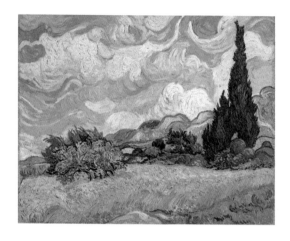

20__ _____

20__ _____ 20__ _____

_____ _____

_____ _____

_____ _____

20__ _____ 20__ _____

_____ _____

_____ _____

_____ _____

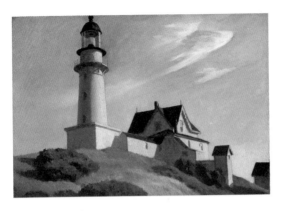

The Lighthouse at Two Lights
Edward Hopper, American, 1882–1967
Hugo Kastor Fund, 1962 62.95

20_ _ _____

20_ _ _____ 20_ _ _____

_____ _____

_____ _____

_____ _____

20_ _ _____ 20_ _ _____

_____ _____

_____ _____

_____ _____

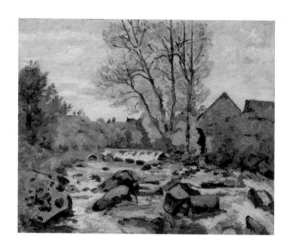

The Bouchardon Mill, Crozant
Armand Guillaumin, French, 1841–1927
Robert Lehman Collection, 1975 1975.1.181

20＿＿ ＿＿＿＿＿＿＿＿＿＿＿＿＿＿＿＿＿＿＿＿＿＿＿

＿＿＿＿＿＿＿＿＿＿＿＿＿＿＿＿＿＿＿＿＿＿＿＿＿＿＿＿＿＿＿

＿＿＿＿＿＿＿＿＿＿＿＿＿＿＿＿＿＿＿＿＿＿＿＿＿＿＿＿＿＿＿

20＿＿ ＿＿＿＿＿＿＿＿＿＿ 20＿＿ ＿＿＿＿＿＿＿＿＿＿

＿＿＿＿＿＿＿＿＿＿＿＿＿＿＿ ＿＿＿＿＿＿＿＿＿＿＿＿＿＿＿

＿＿＿＿＿＿＿＿＿＿＿＿＿＿＿ ＿＿＿＿＿＿＿＿＿＿＿＿＿＿＿

＿＿＿＿＿＿＿＿＿＿＿＿＿＿＿ ＿＿＿＿＿＿＿＿＿＿＿＿＿＿＿

20＿＿ ＿＿＿＿＿＿＿＿＿＿ 20＿＿ ＿＿＿＿＿＿＿＿＿＿

＿＿＿＿＿＿＿＿＿＿＿＿＿＿＿ ＿＿＿＿＿＿＿＿＿＿＿＿＿＿＿

＿＿＿＿＿＿＿＿＿＿＿＿＿＿＿ ＿＿＿＿＿＿＿＿＿＿＿＿＿＿＿

＿＿＿＿＿＿＿＿＿＿＿＿＿＿＿ ＿＿＿＿＿＿＿＿＿＿＿＿＿＿＿

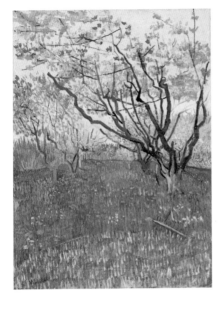

The Flowering Orchard
Vincent van Gogh, Dutch,
1853–1890

The Mr. and Mrs. Henry Ittleson Jr.
Purchase Fund, 1956 56.13

20_ _ _____

20_ _ _____ 20_ _ _____

_____ _____

_____ _____

_____ _____

20_ _ _____ 20_ _ _____

_____ _____

_____ _____

_____ _____

Venice, from the Porch of Madonna della Salute
Joseph Mallord William Turner, British, 1775–1851

Bequest of Cornelius Vanderbilt, 1899 99.31

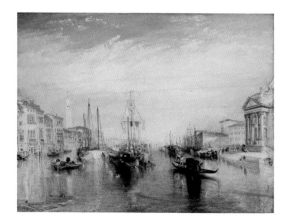

20_ _ _____

20_ _ _____ 20_ _ _____

_____ _____

_____ _____

_____ _____

20_ _ _____ 20_ _ _____

_____ _____

_____ _____

_____ _____

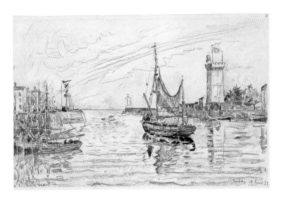

View of Les Sables d'Olonne
Paul Signac, French, 1863–1935

Robert Lehman Collection, 1975 1975.1.724

20__ _____

20__ _____ 20__ _____

_____ _____

_____ _____

_____ _____

20__ _____ 20__ _____

_____ _____

_____ _____

_____ _____

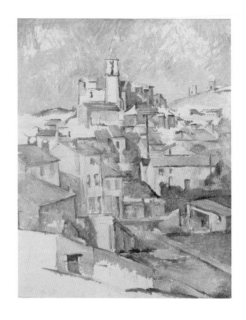

Gardanne

Paul Cézanne,
French, 1839–1906

Gift of Dr. and Mrs. Franz H.
Hirschland, 1957 57.181

20_ _ _____

20_ _ _____ 20_ _ _____

_____ _____

_____ _____

_____ _____

20_ _ _____ 20_ _ _____

_____ _____

_____ _____

_____ _____

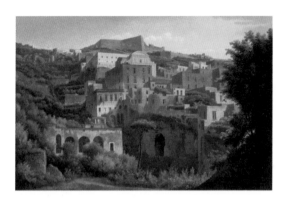

Castel Sant'Elmo from Chiaia, Naples
Alexandre Hyacinthe Dunouy, French, 1757–1841

Thaw Collection, Jointly Owned by The Metropolitan
Museum of Art and The Morgan Library & Museum,
Gift of Eugene V. Thaw, 2009 2009.400.52

20__ _____

20__ _____ 20__ _____

_____ _____

_____ _____

20__ _____ 20__ _____

_____ _____

_____ _____

View of Ornans
Gustave Courbet, French, 1819–1877

Bequest of Alice Tully, 1993 1995.537

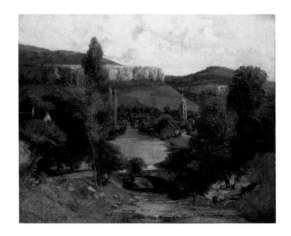

20_ _ _____

20_ _ _____ 20_ _ _____

_____ _____

_____ _____

_____ _____

20_ _ _____ 20_ _ _____

_____ _____

_____ _____

_____ _____

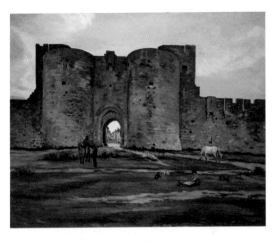

Porte de la Reine at Aigues-Mortes
Jean-Frédéric Bazille, French, 1841–1870

Purchase, Gift of Raymonde Paul, in memory of her brother,
C. Michael Paul, by exchange, 1988 1988.221

20 __ __ _____

20 __ __ _____ 20 __ __ _____

20 __ __ _____ 20 __ __ _____

"Portrait of a Persian Lady",
Folio from the
Davis Album

Islamic, ca. 1736–1737

Theodore M. Davis
Collection, Bequest of
Theodore M. Davis, 1915
30.95.174.32

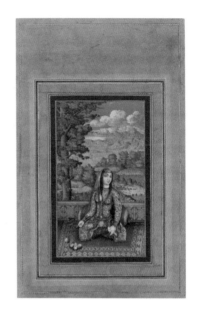

20_ _ _____

20_ _ _____ 20_ _ _____

_____ _____

_____ _____

_____ _____

20_ _ _____ 20_ _ _____

_____ _____

_____ _____

_____ _____

14

Lady of the Lake

Horace Pippin, American, 1888–1946

Bequest of Jane Kendall Gingrich, 1982 1982.55.1

20__ _____

20__ _____ 20__ _____

_____ _____

_____ _____

_____ _____

20__ _____ 20__ _____

_____ _____

_____ _____

_____ _____

*Portrait of a Woman,
Her Head Turned to
the Right, Wearing an
Earring*

**Joseph Wright
(Wright of Derby),**
British, 1734–1797

Rogers Fund, 2007 2007.40

20＿＿ _____

20＿＿ _____ 20＿＿ _____

_____ _____

_____ _____

_____ _____

20＿＿ _____ 20＿＿ _____

_____ _____

_____ _____

_____ _____

**Bacchante
(Grapes or Autumn)**

Auguste Rodin,
French, 1840–1917

Purchase, Charles Ulrick
and Josephine Bay
Foundation Inc. Gift, 1975
1975.312.7

20__ _____

20__ _____ 20__ _____

20__ _____ 20__ _____

AUGUST

17

Salomé

Henri Regnault,
French, 1843–1871

Gift of George F. Baker,
1916. 16.95

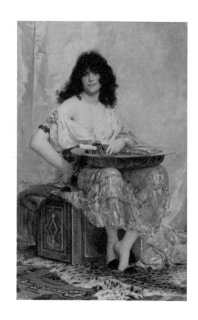

20___ _____

20___ _____ 20___ _____

_____ _____

_____ _____

_____ _____

20___ _____ 20___ _____

_____ _____

_____ _____

_____ _____

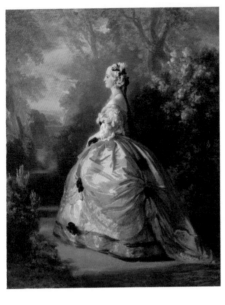

The Empress Eugénie (Eugénie de Montijo, 1826–1920, Condesa de Teba)

Franz Xaver Winterhalter, German, 1805–1873

Purchase, Mr. and Mrs. Claus von Bülow Gift, 1978 1978.403

20__ _____

20__ _____ 20__ _____

_____ _____

_____ _____

_____ _____

20__ _____ 20__ _____

_____ _____

_____ _____

_____ _____

Fragment of a Floor Mosaic with a Personification of Ktisis

Byzantine, 500–550, with modern restoration

Harris Brisbane Dick Fund and Fletcher Fund, 1998; Purchase, Lila Acheson
Wallace Gift, Dodge Fund, and Rogers Fund, 1999 1998.69; 1999.99

20_ _ _____

20_ _ _____ 20_ _ _____

_____ _____

_____ _____

20_ _ _____ 20_ _ _____

_____ _____

_____ _____

_____ _____

20__ _____

20__ _____ 20__ _____

_____ _____

_____ _____

_____ _____

20__ _____ 20__ _____

_____ _____

_____ _____

_____ _____

The Freedman

**John Quincy Adams
Ward,** American,
1830–1910

Gift of Charles Anthony
Lamb and Barea Lamb
Seeley, in memory of
their grandfather, Charles
Rollinson Lamb, 1979
1979.394

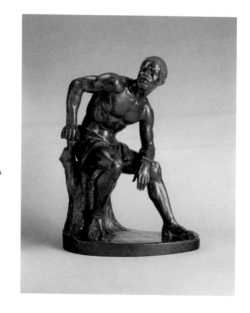

20___ _____

20___ _____ 20___ _____

_____ _____

_____ _____

20___ _____ 20___ _____

_____ _____

_____ _____

*Studies for the
Libyan Sibyl* (recto)

**Michelangelo
Buonarroti,** Italian,
1475–1564

Purchase, Joseph Pulitzer
Bequest, 1924 24.197.2

20__ _____

20__ _____ 20__ _____

_____ _____

_____ _____

_____ _____

20__ _____ 20__ _____

_____ _____

_____ _____

_____ _____

Île aux Fleurs near Vétheuil
Claude Monet, French, 1840–1926

Bequest of Julia W. Emmons, 1956 56.135.5

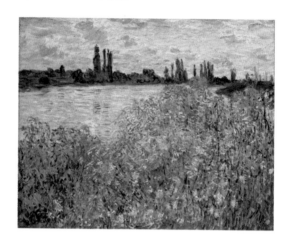

20__ _____

20__ _____ 20__ _____

_____ _____

_____ _____

_____ _____

20__ _____ 20__ _____

_____ _____

_____ _____

_____ _____

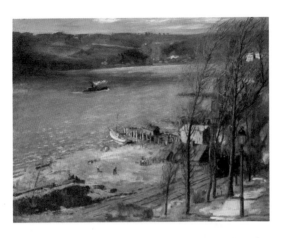

Up the Hudson
George Bellows, American, 1882–1925
Gift of Hugo Reisinger, 1911 11.17

20＿＿ ──────────────────────────

────────────────────────────────

────────────────────────────────

20＿＿ ────────────── 20＿＿ ──────────────

────────────────── ──────────────────

────────────────── ──────────────────

────────────────── ──────────────────

20＿＿ ────────────── 20＿＿ ──────────────

────────────────── ──────────────────

────────────────── ──────────────────

────────────────── ──────────────────

The Molo, Venice,
from the Bacino
di San Marco

Luca Carlevaris, Italian,
1663/65–1730

Robert Lehman Collection,
1975 1975.1.87

20__ _____

20__ _____ 20__ _____

_____ _____

_____ _____

_____ _____

20__ _____ 20__ _____

_____ _____

_____ _____

_____ _____

Padua: The River Bacchiglione and the Porta Portello
Canaletto (Giovanni Antonio Canal), Italian, 1697–1768

Robert Lehman Collection, 1975 1975.1.293

20__ _____

20__ _____ 20__ _____

_____ _____

_____ _____

_____ _____

20__ _____ 20__ _____

_____ _____

_____ _____

_____ _____

Apples

Paul Cézanne, French, 1839–1906

The Mr. and Mrs. Henry Ittleson Jr. Purchase Fund, 1961 61.103

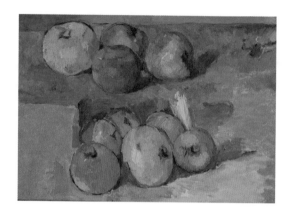

20___ _____

20___ _____ 20___ _____

_____ _____

_____ _____

_____ _____

20___ _____ 20___ _____

_____ _____

_____ _____

_____ _____

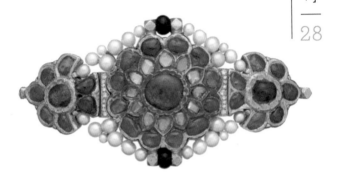

20_ _ _____

20_ _ _____ 20_ _ _____

_____ _____

_____ _____

_____ _____

20_ _ _____ 20_ _ _____

_____ _____

_____ _____

_____ _____

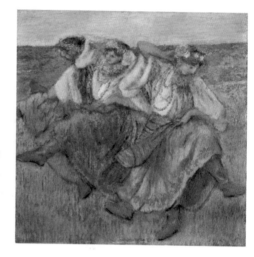

Russian Dancers

Edgar Degas,
French, 1834–1917

Robert Lehman
Collection, 1975
1975.1.166

20＿＿ _____

20＿＿ _____ 　　20＿＿ _____

_____ 　　_____

_____ 　　_____

_____ 　　_____

20＿＿ _____ 　　20＿＿ _____

_____ 　　_____

_____ 　　_____

_____ 　　_____

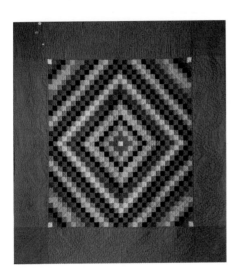

Quilt, Sunshine and Shadow pattern

American, ca. 1930

Purchase, Eva Gebhard-
Gourgaud Foundation
Gift, 1973 1973.94

20__ _____

20__ _____ 20__ _____

_____ _____

_____ _____

_____ _____

20__ _____ 20__ _____

_____ _____

_____ _____

_____ _____

On the Southern Plains
Frederic Remington, American, 1861–1909

Gift of Several Gentlemen, 1911 11.192

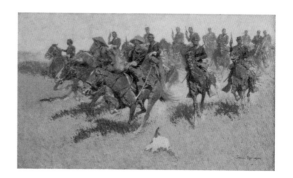

20__ _____

20__ _____ 20__ _____

_____ _____

_____ _____

_____ _____

20__ _____ 20__ _____

_____ _____

_____ _____

_____ _____

The Broncho Buster
Frederic Remington,
American, 1861–1909

20_ _ _____

20_ _ _____ 20_ _ _____

_____ _____

_____ _____

_____ _____

20_ _ _____ 20_ _ _____

_____ _____

_____ _____

_____ _____

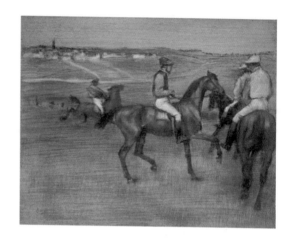

Race Horses
Edgar Degas, French, 1834–1917

The Walter H. and Leonore Annenberg Collection,
Gift of Walter H. and Leonore Annenberg, 1999,
Bequest of Walter H. Annenberg, 2002 1999.288.3

20____ _____

20____ _____ 20____ _____

20____ _____ 20____ _____

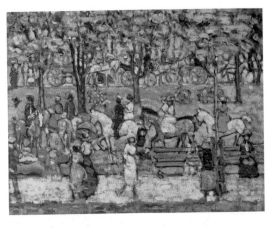

Central Park
Maurice Brazil Prendergast, American, 1858–1924
George A. Hearn Fund, 1950 50.25

20_ _

20_ _ 20_ _

20_ _ 20_ _

The Start of the Race of the Riderless Horses
Horace Vernet, French, 1789–1863

Catharine Lorillard Wolfe Collection, Bequest of Catharine Lorillard Wolfe, 1887 87.15.47

20 _ _ _____

20 _ _ _____ 20 _ _ _____

_____ _____

_____ _____

_____ _____

20 _ _ _____ 20 _ _ _____

_____ _____

_____ _____

_____ _____

A Stallion

Habiballah of Sava, Islamic, active ca. 1590–1610

Purchase, Louis E. and Theresa S. Seley Purchase Fund for Islamic Art, The
Edward Joseph Gallagher III Memorial Collection, Edward J. Gallagher Jr.
Bequest, and Richard S. Perkins and Margaret Mushekian Gifts, 1992 1992.51

20__ _____

20__ _____ 20__ _____

_____ _____

_____ _____

_____ _____

20__ _____ 20__ _____

_____ _____

_____ _____

_____ _____

The Harvesters

Pieter Bruegel the Elder, Netherlandish, ca. 1525–1569

Rogers Fund, 1919 19.164

20_ _ _____

20_ _ _____ 20_ _ _____

_____ _____

_____ _____

_____ _____

20_ _ _____ 20_ _ _____

_____ _____

_____ _____

_____ _____

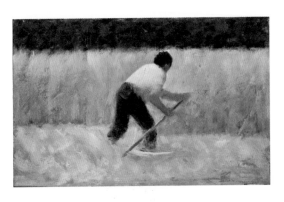

The Mower
Georges Seurat, French, 1859–1891
Robert Lehman Collection, 1975 1975.1.206

20__ _____

20__ _____ 20__ _____

_____ _____

_____ _____

_____ _____

20__ _____ 20__ _____

_____ _____

_____ _____

_____ _____

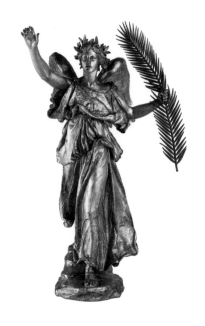

Victory

Augustus Saint-Gaudens, American, 1848–1907

Rogers Fund, 1917 17.90.1

20__ _____

20__ _____ 20__ _____

_____ _____

_____ _____

_____ _____

20__ _____ 20__ _____

_____ _____

_____ _____

_____ _____

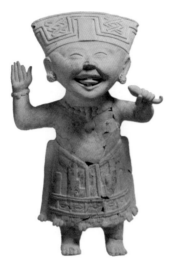

"Smiling" Figure

Remojadas (Mexico,
Mesoamerica,
Veracruz), ca.
7th-8th century

20_ _ _____

20_ _ _____ 20_ _ _____

_____ _____

_____ _____

_____ _____

20_ _ _____ 20_ _ _____

_____ _____

_____ _____

_____ _____

The Singer of Amun Nany's Funerary Papyrus

Egyptian (Upper Egypt, Thebes, Deir el-Bahri, Tomb of
Meritamun (TT 358, MMA 65), first corridor, inside Osiris
figure, MMA excavations, 1928–29), Third intermediate
Period, Dynasty 21, reign of Psusennes I-II (ca. 1050 B.C.)

Rogers Fund, 1930 30.3.31

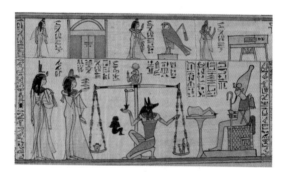

20_ _ _____

20_ _ _____ 20_ _ _____

_____ _____

_____ _____

_____ _____

20_ _ _____ 20_ _ _____

_____ _____

_____ _____

_____ _____

11

Estate Figure

Egyptian (Thebes,
Middle Kingdom),
Dynasty 12 (ca.
1981–1975 B.C.)

Rogers Fund and Edward S.
Harkness Gift, 1920 20.3.7

20__ _____

20__ _____ 20__ _____

_____ _____

_____ _____

_____ _____

20__ _____ 20__ _____

_____ _____

_____ _____

_____ _____

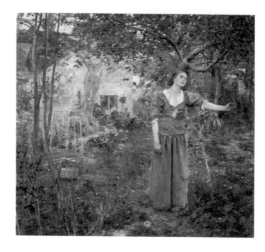

Joan of Arc
Jules Bastien-Lepage, French, 1848–1884

Gift of Erwin Davis, 1889 89.21.1

20_ _ _____

20_ _ _____ 20_ _ _____

_____ _____

_____ _____

_____ _____

20_ _ _____ 20_ _ _____

_____ _____

_____ _____

_____ _____

*Maude Adams
(1872–1953) as
Joan of Arc*

Alphonse Mucha,
Czech, 1860–1939

Gift of A. J. Kobler, 1920
20.33

20__ _____

20__ _____ 20__ _____

_____ _____

_____ _____

_____ _____

20__ _____ 20__ _____

_____ _____

_____ _____

_____ _____

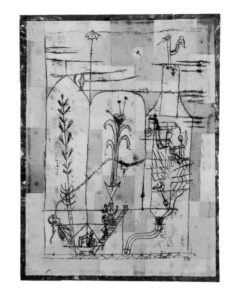

Tale à la Hoffmann

Paul Klee, German
(b. Switzerland),
1879–1940

The Berggruen Klee
Collection, 1984 1984.315.26

20__ _____

20__ _____

20__ _____

20__ _____

20__ _____

Oriental Pleasure Garden

Paul Klee, German (b. Switzerland), 1879–1940

The Berggruen Klee Collection, 1984 1984.315.41

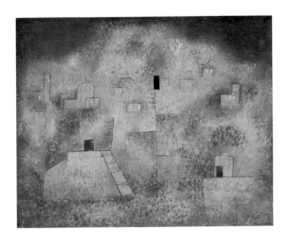

20_ _ _____

20_ _ _____ 20_ _ _____

_____ _____

_____ _____

_____ _____

20_ _ _____ 20_ _ _____

_____ _____

_____ _____

_____ _____

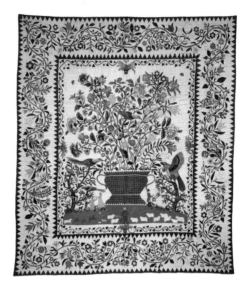

*Phebe Warner
Coverlet*

**Probably Sarah
Furman Warner
Williams,**
American, b. 1764

Gift of Catharine E.
Cotheal, 1938 38.59

20__ _____

20__ _____ 20__ _____

_____ _____

_____ _____

_____ _____

20__ _____ 20__ _____

_____ _____

_____ _____

_____ _____

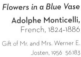

Flowers in a Blue Vase

Adolphe Monticelli,
French, 1824–1886

Gift of Mr. and Mrs. Werner E.
Josten, 1956 56.183

20_ _ _____

20_ _ _____ 20_ _ _____

_____ _____

_____ _____

_____ _____

20_ _ _____ 20_ _ _____

_____ _____

_____ _____

_____ _____

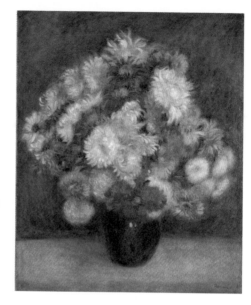

Bouquet of Chrysanthemums

Auguste Renoir,
French, 1841–1919

The Walter H. and
Leonore Annenberg
Collection, Bequest of
Walter H. Annenberg,
2002 2003.20.10

20_ _ _____

20_ _ _____ 20_ _ _____

_____ _____

_____ _____

20_ _ _____ 20_ _ _____

_____ _____

_____ _____

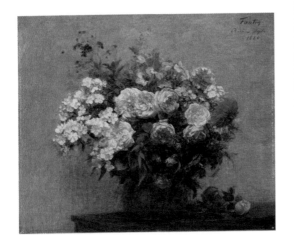

20__ _____

20__ _____ 20__ _____

_____ _____

_____ _____

_____ _____

20__ _____ 20__ _____

_____ _____

_____ _____

_____ _____

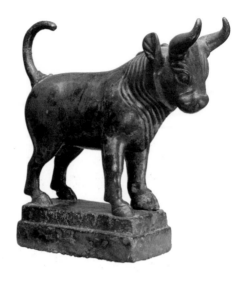

Standing bull

Southwestern
Arabian, ca.
mid-1st millennium
B.C.

Rogers Fund, 1947
47.100.85

20__ _____

20__ _____ 20__ _____

_____ _____

_____ _____

_____ _____

20__ _____ 20__ _____

_____ _____

_____ _____

_____ _____

Bullfight in a Divided Ring
Attributed to Goya (Francisco de Goya y Lucientes),
Spanish, 1746–1828

20_ _ _____

20_ _ _____ 20_ _ _____
_____ _____
_____ _____
_____ _____

20_ _ _____ 20_ _ _____
_____ _____
_____ _____
_____ _____

Autumn Oaks

George Inness, American, 1825–1894

Gift of George I. Seney, 1887 87.8.8

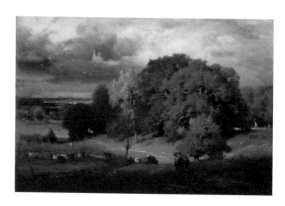

20__ _____

20__ _____ 20__ _____

_____ _____

_____ _____

20__ _____ 20__ _____

_____ _____

_____ _____

Hillside Pastures—September

Willard Metcalf, American, 1858–1925

Bequest of Miss Adelaide Milton de Groot (1876–1967), 1967 67.187.134

20__ _____

20__ _____ 20__ _____

_____ _____

_____ _____

20__ _____ 20__ _____

_____ _____

_____ _____

_____ _____

The Weeders
Jules Breton, French, 1827-1906

Bequest of Collis P. Huntington, 1900 25.110.66

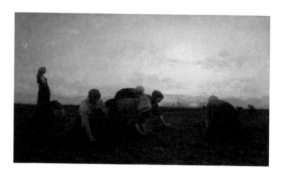

20_ _ _____

20_ _ _____ 20_ _ _____

_____ _____

_____ _____

_____ _____

20_ _ _____ 20_ _ _____

_____ _____

_____ _____

_____ _____

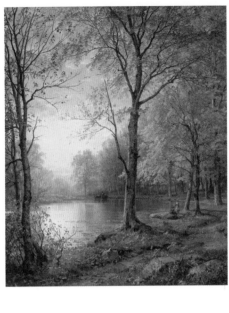

Indian Summer

William Trost Richards, American, 1833–1905

Bequest of Collis P. Huntington, 1900 25.110.6

20__ _____

20__ _____

20__ _____

20__ _____

20__ _____

SEPTEMBER | 26

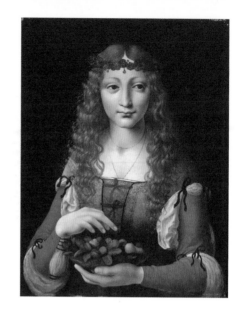

Girl with Cherries

Attributed to Giovanni Ambrogio de Predis, Italian (Milan), active by 1472–died after 1508

Marquand Collection, Gift of Henry G. Marquand, 1890 91.26.5

20__ _____

20__ _____ 20__ _____

_____ _____

_____ _____

_____ _____

20__ _____ 20__ _____

_____ _____

_____ _____

_____ _____

Maple Leaves

Shibata Zeshin,
Japanese, 1807–1891

20__ _____

20__ _____ 20__ _____

20__ _____ 20__ _____

SEPTEMBER

28

The Persimmon Tree

Sakai Hōitsu,
Japanese,
1761–1828

Rogers Fund, 1957
57.156.3

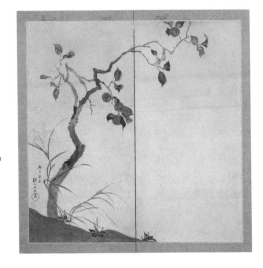

20__ _____

20__ _____ 20__ _____

_____ _____

_____ _____

_____ _____

20__ _____ 20__ _____

_____ _____

_____ _____

_____ _____

*Noh Robe (Nuihaku)
with Design
of Butterflies,
Chrysanthemums,
Maple Leaves, and
Miscanthus Grass*

Japanese, Edo
period (1615–1868)

Purchase, Joseph Pulitzer
Bequest, 1932 32.30.1

20__ _____

20__ _____ 20__ _____

_____ _____

_____ _____

_____ _____

20__ _____ 20__ _____

_____ _____

_____ _____

_____ _____

Lamp

Tiffany Studios,
American,
1902–1932

Bequest of William S.
Lieberman, 2005
2007.4998a, b

20__ _____

20__ _____ 20__ _____

_____ _____

_____ _____

_____ _____

20__ _____ 20__ _____

_____ _____

_____ _____

_____ _____

Still Life: Balsam Apple and Vegetables

James Peale, American, 1749–1831

Maria DeWitt Jesup Fund, 1939 39.52

20__ _____

20__ _____ 20__ _____

_____ _____

_____ _____

_____ _____

20__ _____ 20__ _____

_____ _____

_____ _____

_____ _____

Birth and Baptismal Certificate

American, 1822

Gift of Mrs. Robert W. de Forest, 1933 34.100.70

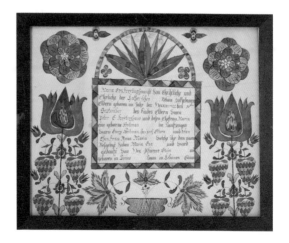

20___ _____

20___ _____ 20___ _____

_____ _____

_____ _____

_____ _____

20___ _____ 20___ _____

_____ _____

_____ _____

_____ _____

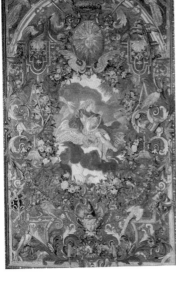

Seasons and Elements (Air) (set of four)

Attributed to Charles Le Brun, French, 1619–1690

Border probably designed by Jean Lemoyen le Lorrain, French, 1637/38–1709

Rogers Fund, 1946 46.43.4

20__ _____

20__ _____

20__ _____

20__ _____

20__ _____

OCTOBER

4

**Yamantaka,
Destroyer of the
God of Death**

Tibetan, early 18th
century

Purchase, Florance
Waterbury Bequest,
1969 69.71

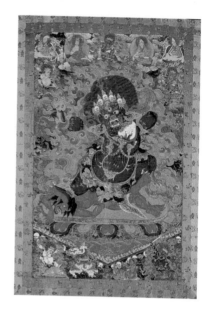

20__ _____

20__ _____ 20__ _____

_____ _____

_____ _____

_____ _____

20__ _____ 20__ _____

_____ _____

_____ _____

_____ _____

Temple Gardens
Paul Klee, German (b. Switzerland), 1879–1940
The Berggruen Klee Collection, 1987 1987.455.2

20__ _____

20__ _____ 20__ _____

_____ _____

_____ _____

_____ _____

20__ _____ 20__ _____

_____ _____

_____ _____

_____ _____

Applique in the shape of a lion's head
Achaemenid (Iran), ca. 6th–4th century B.C.
Gift of Khalil Rabenou, 1956 56.154.1

20_ _ _____

20_ _ _____ 20_ _ _____

_____ _____

_____ _____

_____ _____

20_ _ _____ 20_ _ _____

_____ _____

_____ _____

_____ _____

The Repast of the Lion
Henri Rousseau (le Douanier), French, 1844–1910

Bequest of Sam A. Lewisohn, 1951 51.112.5

20___ _____

20___ _____

20___ _____

20___ _____

20___ _____

I Saw the Figure 5 in Gold

Charles Demuth, American, 1883–1935

Alfred Stieglitz Collection, 1949 49.59.1

20__ _____

20__ _____ 20__ _____

_____ _____

_____ _____

_____ _____

20__ _____ 20__ _____

_____ _____

_____ _____

_____ _____

Silk Animal Carpet

Islamic (probably
Kashan), second half
of the 16th century

Bequest of Benjamin
Altman, 1913 14.40.721

20＿＿ _____

20＿＿ _____ 20＿＿ _____

_____ _____

_____ _____

20＿＿ _____ 20＿＿ _____

_____ _____

_____ _____

*L'Arlésienne:
Madame Joseph-
Michel Ginoux
(Marie Julien,
1848–1911)*

Vincent van Gogh,
Dutch, 1853–1890

Bequest of Sam A.
Lewisohn, 1951. 51.112.3

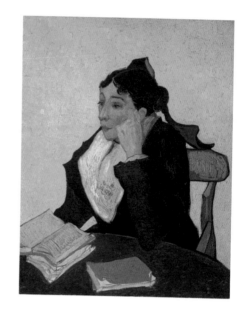

20_ _ _____

20_ _ _____ 20_ _ _____

_____ _____

_____ _____

_____ _____

20_ _ _____ 20_ _ _____

_____ _____

_____ _____

_____ _____

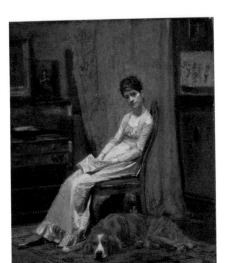

*The Artist's Wife
and His Setter Dog*

Thomas Eakins,
American, 1844–1916

Fletcher Fund, 1923
23.139

20＿＿ _____

20＿＿ _____ 20＿＿ _____

20＿＿ _____ 20＿＿ _____

Reproduction of the "Great S-spiral frieze" fresco
Emile Gilliéron père, French, 1911 or early 1912
Mycenaean, Late Helladic III (ca. 1400–1200 B.C.)
Dodge Fund, 1912 12.58.2

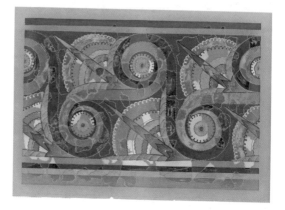

20__ __ _____

20__ __ _____ 20__ __ _____

_____ _____

_____ _____

_____ _____

20__ __ _____ 20__ __ _____

_____ _____

_____ _____

_____ _____

*Costume study for
Vaslav Nijinsky in the
role of Iksender in the
ballet "La Péri"*

Léon Bakst, Russian,
1866–1924

Gift of Sir Joseph Duveen,
1922 22.226.1

20__ _____

20__ _____ 20__ _____

_____ _____

_____ _____

20__ _____ 20__ _____

_____ _____

_____ _____

Jack Rose (Rose Jacqueminot), from the *Flowers* series for Old Judge Cigarettes

Issued by Goodwin & Company, American, 1890

George S. Harris & Sons, American

The Jefferson R. Burdick Collection, Gift of Jefferson R. Burdick 63.350.214.164.47

JACK ROSE.
(Rose Jacqueminot.)

20__ _____

20__ _____ 20__ _____
_____ _____
_____ _____
_____ _____

20__ _____ 20__ _____
_____ _____
_____ _____
_____ _____

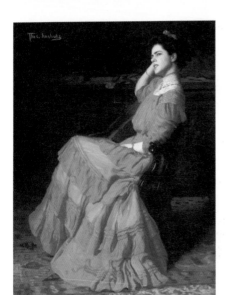

A Rose

Thomas Anshutz,
American, 1851–1912

Marguerite and Frank A.
Cosgrove Jr. Fund, 1993
1993.324

20__ _____

20__ _____ 20__ _____

20__ _____ 20__ _____

OCTOBER

16

Carmelita Requena

Thomas Eakins,
American, 1844–1916

Bequest of Mary Cushing
Fosburgh, 1978 1979.135.2

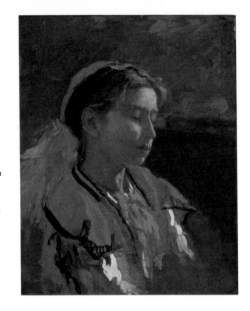

20_ _ _____

20_ _ _____ 20_ _ _____

_____ _____

_____ _____

_____ _____

20_ _ _____ 20_ _ _____

_____ _____

_____ _____

_____ _____

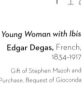

Young Woman with Ibis
Edgar Degas, French,
1834–1917

Gift of Stephen Mazoh and
Purchase, Bequest of Gioconda
King, by exchange, 2008
2008.277

20__ _____

20__ _____ 20__ _____

_____ _____

_____ _____

_____ _____

20__ _____ 20__ _____

_____ _____

_____ _____

_____ _____

OCTOBER

18

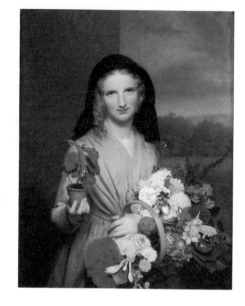

The Flower Girl

Charles Cromwell Ingham, American (b. Ireland), 1786–1863

Gift of William Church Osborn, 1902 02.7.1

20_ _ _____

20_ _ _____ 20_ _ _____

_____ _____

_____ _____

_____ _____

20_ _ _____ 20_ _ _____

_____ _____

_____ _____

_____ _____

Still Life: Flowers and Fruit

Severin Roesen, American (b. Prussia), 1816–1872?

Purchase, Bequest of Charles Allen Munn, by exchange, Fosburgh Fund Inc. and Mr. and Mrs. J. William Middendorf II Gifts, and Henry G. Keasbey Bequest, 1967 67.111

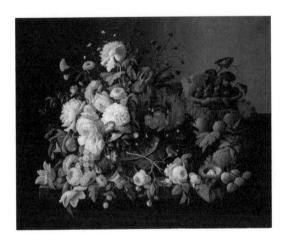

20__ _____

20__ _____ 20__ _____

_____ _____

_____ _____

_____ _____

20__ _____ 20__ _____

_____ _____

_____ _____

_____ _____

*The Belles Heures of
Jean de France, duc
de Berry*

**Herman, Paul, and
Jean de Limbourg,**
Franco-Netherlandish,
active by 1399–1416

The Cloisters Collection, 1954
54.1.1a, b

20__ _____

20__ _____ 20__ _____

_____ _____

_____ _____

_____ _____

20__ _____ 20__ _____

_____ _____

_____ _____

_____ _____

Theodosius Arrives at Ephesus, from a Scene from the
Legend of the Seven Sleepers of Ephesus

French (Rouen), ca. 1200–1210

The Cloisters Collection, 1980 1980.263.4

20__ _____

20__ _____ 20__ _____

_____ _____

_____ _____

20__ _____ 20__ _____

_____ _____

_____ _____

*Avenue of the Allies,
Great Britain, 1918*

Childe Hassam,
American, 1859–1935

Bequest of Miss Adelaide
Milton de Groot (1876–1967),
1967 67.187.127

20＿＿ _____

20＿＿ _____ 20＿＿ _____

_____ _____

_____ _____

_____ _____

20＿＿ _____ 20＿＿ _____

_____ _____

_____ _____

_____ _____

Portrait of
a German Officer

Marsden Hartley,
American, 1877–1943

Alfred Stieglitz Collection,
1949 49.70.42

OCTOBER

23

20__ _____

20__ _____ 20__ _____

_____ _____

_____ _____

_____ _____

20__ _____ 20__ _____

_____ _____

_____ _____

_____ _____

Pair of Minbar Doors

Islamic, ca. 1325–1330

Edward C. Moore Collection,
Bequest of Edward C. Moore,
1891 911.2064

20___ _____

20___ _____ 20___ _____

_____ _____

_____ _____

_____ _____

20___ _____ 20___ _____

_____ _____

_____ _____

_____ _____

*"Rosette Bearing the
Names and Titles
of Shah Jahan",*
Folio from the *Shah
Jahan Album*

Indian, Mughal period
(ca. 1526–1858)

Purchase, Rogers Fund and The
Kevorkian Foundation Gift, 1955
55.121.10.39

20__ _____

20__ _____ 20__ _____

_____ _____

_____ _____

_____ _____

20__ _____ 20__ _____

_____ _____

_____ _____

_____ _____

Crouching Tiger

Eugène Delacroix, French, 1798–1863

Gift from the Karen B. Cohen Collection of Eugène Delacroix,
in honor of Sanford I. Weill, 2013 2013.1135.5

20_ _ _____

20_ _ _____ 20_ _ _____

_____ _____

_____ _____

_____ _____

20_ _ _____ 20_ _ _____

_____ _____

_____ _____

_____ _____

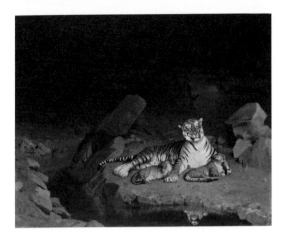

Tiger and Cubs
Jean-Léon Gérôme, French, 1824–1904

Bequest of Susan P. Colgate, in memory of her husband, Romulus R. Colgate, 1936 36.162.4

20__ _____

20__ _____ 20__ _____

20__ _____ 20__ _____

## OCTOBER

## 28

*Relief plaque
with face of
an owl*

Egyptian, Late
Period–Ptolemaic
Period (400–30
B.C.)

Rogers Fund, 1907
07.228.11

20_ _ _____

20_ _ _____ 20_ _ _____

_____ _____

_____ _____

_____ _____

20_ _ _____ 20_ _ _____

_____ _____

_____ _____

_____ _____

Owl Finial

Zenu or Sinu
(Colombia), ca.
5th–10th century

The Michael C.
Rockefeller Memorial
Collection, Bequest of
Nelson A. Rockefeller,
1979 1979.206.920

20 _ _ _____

20 _ _ _____ 20 _ _ _____

_____ _____

_____ _____

_____ _____

20 _ _ _____ 20 _ _ _____

_____ _____

_____ _____

_____ _____

Dancer in Green
Edgar Degas,
French, 1834–1917

Bequest of Joan
Whitney Payson, 1975
1976.201.7

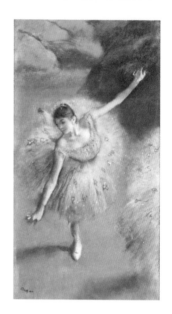

20_ _ _____

20_ _ _____ 20_ _ _____

_____ _____

_____ _____

_____ _____

20_ _ _____ 20_ _ _____

_____ _____

_____ _____

_____ _____

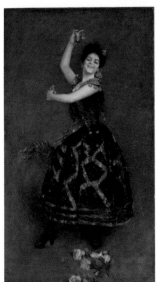

OCTOBER | 31

20__ _____

20__ _____ 20__ _____

_____ _____

_____ _____

_____ _____

20__ _____ 20__ _____

_____ _____

_____ _____

_____ _____

Penelope

Charles-François Marchal, French,
1825–1877

Gift of Mrs. Adolf Obrig,
in memory of her husband,
1917 17.138.2

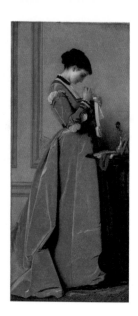

20__ _____

20__ _____ 20__ _____

_____ _____

_____ _____

_____ _____

20__ _____ 20__ _____

_____ _____

_____ _____

_____ _____

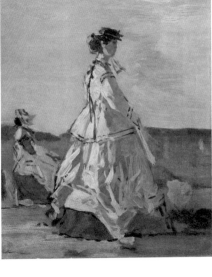

*Princess Pauline
Metternich (1836–1921)
on the Beach*

Eugène Boudin,
French, 1824–1898

The Walter H. and Leonore
Annenberg Collection, Gift
of Walter H. and Leonore
Annenberg, 1999, Bequest of
Walter H. Annenberg, 2002
1999.288.1

20_ _ _____

20_ _ _____ 20_ _ _____

_____ _____

_____ _____

20_ _ _____ 20_ _ _____

_____ _____

_____ _____

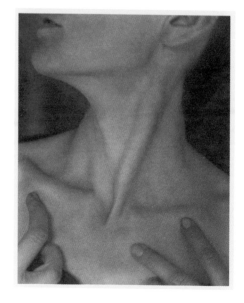

*Georgia O'Keeffe—
Neck*

Alfred Stieglitz,
American, 1864–1946

Gift of Georgia O'Keeffe,
through the generosity
of The Georgia O'Keeffe
Foundation and Jennifer
and Joseph Duke, 1997
1997.61.19

20＿＿ _____

20＿＿ _____ 20＿＿ _____

_____ _____

_____ _____

_____ _____

20＿＿ _____ 20＿＿ _____

_____ _____

_____ _____

_____ _____

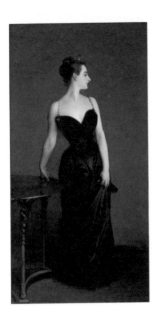

Madame X (Madame Pierre Gautreau)

John Singer Sargent,
American, 1856–1925

Arthur Hoppock Hearn Fund,
1916 16.53

NOVEMBER | 4

20＿＿ _____

20＿＿ _____ 20＿＿ _____

_____ _____

_____ _____

_____ _____

20＿＿ _____ 20＿＿ _____

_____ _____

_____ _____

_____ _____

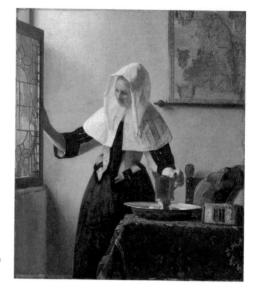

*Young Woman
with a Water
Pitcher*

**Johannes
Vermeer,** Dutch,
1632–1675

Marquand Collection,
Gift of Henry G.
Marquand, 1889 89.15.21

20__ _____

20__ _____ 20__ _____

_____ _____

_____ _____

_____ _____

20__ _____ 20__ _____

_____ _____

_____ _____

_____ _____

*Study Head of
a Woman*

**Jean-Baptiste
Greuze,** French,
1725–1805

Purchase, 1871 71.91

20__ _____

20__ _____ 20__ _____

_____ _____

_____ _____

_____ _____

20__ _____ 20__ _____

_____ _____

_____ _____

_____ _____

Studies of a Young Woman
Adolph Menzel, German, 1815–1905
Robert Lehman Collection, 1975 1975.1.869

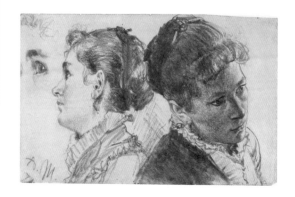

20___ _____

20___ _____ 20___ _____

_____ _____

_____ _____

_____ _____

20___ _____ 20___ _____

_____ _____

_____ _____

_____ _____

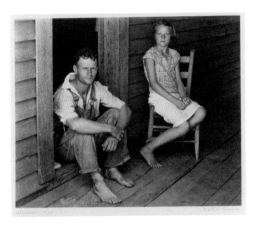

[Floyd and Lucille Burroughs on Porch, Hale County, Alabama]

Walker Evans, American, 1903–1975

20__ _____

20__ _____ 20__ _____

_____ _____

_____ _____

20__ _____ 20__ _____

_____ _____

_____ _____

_____ _____

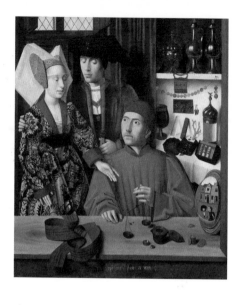

A Goldsmith in his Shop

Petrus Christus,
Netherlandish, active
by 1444–died 1475/76

Robert Lehman Collection,
1975 1975.1.110

20_ _ _____

20_ _ _____ 20_ _ _____

_____ _____

_____ _____

_____ _____

20_ _ _____ 20_ _ _____

_____ _____

_____ _____

_____ _____

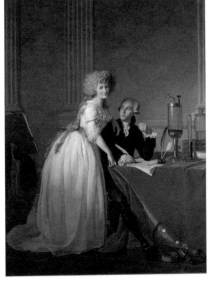

20__ _____

20__ _____ 20__ _____

_____ _____

_____ _____

_____ _____

20__ _____ 20__ _____

_____ _____

_____ _____

_____ _____

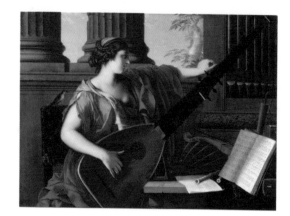

Allegory of Music
Laurent de La Hyre, French, 1606–1656

Charles B. Curtis Fund, 1950 50.189

20__ _____

20__ _____ 20__ _____

_____ _____

_____ _____

_____ _____

20__ _____ 20__ _____

_____ _____

_____ _____

_____ _____

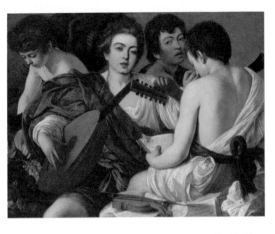

The Musicians
Caravaggio (Michelangelo Merisi), Italian, 1571–1610
Rogers Fund, 1952 52.81

20__ _____

20__ _____ 20__ _____

_____ _____

_____ _____

_____ _____

20__ _____ 20__ _____

_____ _____

_____ _____

_____ _____

Portland vase

Josiah Wedgwood and Sons, British, 1759–present

Gift of Henry G. Marquand, 1894 94.4.172

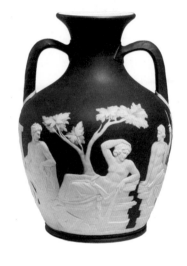

20__ __ _____

20__ __ _____ 20__ __ _____

_____ _____

_____ _____

_____ _____

20__ __ _____ 20__ __ _____

_____ _____

_____ _____

_____ _____

Terracotta amphora

**Attributed to the
Berlin Painter,** Greek,
Attic, Late Archaic
(ca. 490 B.C.)

Fletcher Fund, 1956 56.171.38

20_ _ _____

20_ _ _____ 20_ _ _____

_____ _____

_____ _____

_____ _____

20_ _ _____ 20_ _ _____

_____ _____

_____ _____

_____ _____

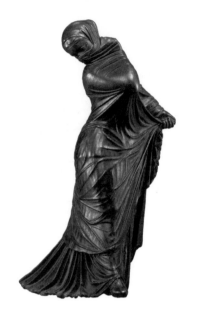

**Bronze statuette
of a veiled and
masked dancer**

Greek, Hellenistic
period, 3rd-2nd
century B.C.

Bequest of Walter C.
Baker, 1971 1972.118.95

20___ _____

20___ _____ 20___ _____

_____ _____

_____ _____

20___ _____ 20___ _____

_____ _____

_____ _____

_____ _____

The Singer in Green

Edgar Degas,
French, 1834–1917

Bequest of Stephen C.
Clark, 1960 61.101.7

20__ _____

20__ _____ 20__ _____

_____ _____

_____ _____

_____ _____

20__ _____ 20__ _____

_____ _____

_____ _____

_____ _____

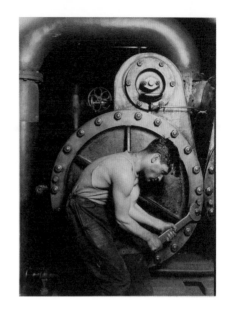

Steamfitter

Lewis Hine,
American, 1874–1940

Ford Motor Company
Collection, Gift of Ford
Motor Company and
John C. Waddell, 1987
1987.1100.146

20＿＿ _____

20＿＿ _____ 20＿＿ _____

_____ _____

_____ _____

_____ _____

20＿＿ _____ 20＿＿ _____

_____ _____

_____ _____

_____ _____

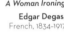

NOVEMBER

18

A Woman Ironing
Edgar Degas,
French, 1834–1917

H. O. Havemeyer Collection,
Bequest of Mrs. H. O.
Havemeyer, 1929 29.100.46

20__ _____

20__ _____ 20__ _____

_____ _____

_____ _____

_____ _____

20__ _____ 20__ _____

_____ _____

_____ _____

_____ _____

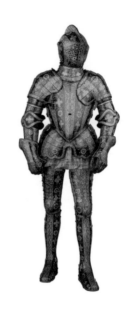

*Armor Garniture
of George Clifford
(1558–1605), Third Earl
of Cumberland*

**Made under the
direction of Jacob
Halder,** British,
1558–1608

Munsey Fund, 1932
32.130.6a–y

20_ _ _____

20_ _ _____ 20_ _ _____

_____ _____

_____ _____

20_ _ _____ 20_ _ _____

_____ _____

_____ _____

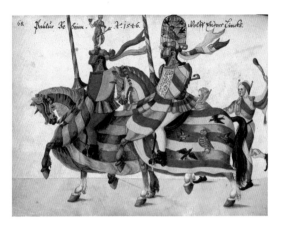

Album of Tournaments and Parades in Nuremberg
German (Nuremberg), late 16th–mid-17th century

20_ _ _____

20_ _ _____ 20_ _ _____

_____ _____

_____ _____

_____ _____

20_ _ _____ 20_ _ _____

_____ _____

_____ _____

_____ _____

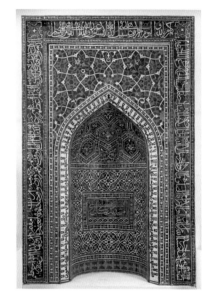

Mihrab (Prayer Niche)

Islamic (Isfahan), A.H.
755/A.D. 1354–1355

Harris Brisbane Dick Fund,
1939 39.20

20__ _____

20__ _____ 20__ _____

_____ _____

_____ _____

_____ _____

20__ _____ 20__ _____

_____ _____

_____ _____

_____ _____

Two Panels with striding lions

Babylonian (Mesopotamia), ca.
604–562 B.C.

Fletcher Fund, 1931 31.13.1–.2

20＿＿ _____

20＿＿ _____ 20＿＿ _____

20＿＿ _____ 20＿＿ _____

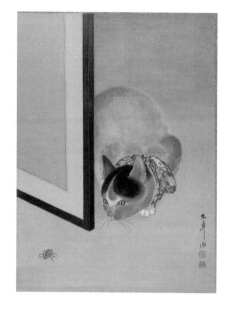

Cat Watching a Spider

Ōide Tōkō, Japanese, 1841–1905

Charles Stewart Smith Collection, Gift of Mrs. Charles Stewart Smith, Charles Stewart Smith Jr., and Howard Caswell Smith, in memory of Charles Stewart Smith, 1914 14.76.61.73

20_ _ _____

20_ _ _____ 20_ _ _____

_____ _____

_____ _____

_____ _____

20_ _ _____ 20_ _ _____

_____ _____

_____ _____

_____ _____

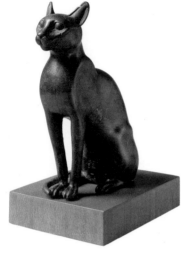

***Cat Statuette
intended to contain a
mummified cat***

Egyptian,
Ptolemaic Period
(ca. 332–30 B.C.)

Harris Brisbane Dick Fund,
1956 56.16.1

20__ _____

20__ _____ 20__ _____

_____ _____

_____ _____

_____ _____

20__ _____ 20__ _____

_____ _____

_____ _____

_____ _____

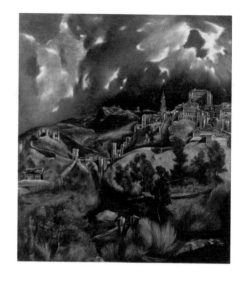

View of Toledo

El Greco, Greek, 1540/41-1614

H. O. Havemeyer
Collection, Bequest of
Mrs. H. O. Havemeyer,
1929 29.100.6

20__ _____

20__ _____ 20__ _____

_____ _____

_____ _____

20__ _____ 20__ _____

_____ _____

_____ _____

_____ _____

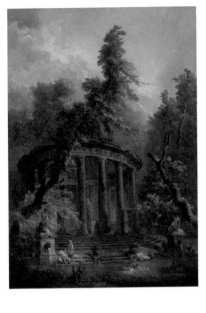

The Bathing Pool
Hubert Robert,
French, 1733–1808

Gift of J. Pierpont Morgan,
1917 17.190.29

20__ _____

20__ _____ 20__ _____

20__ _____ 20__ _____

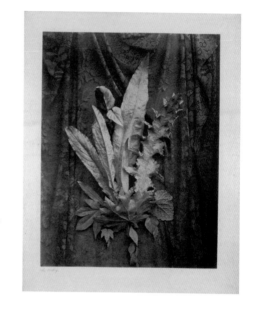

*[Study of Leaves
on a Background
of Floral Lace]*

**Charles Hippolyte
Aubry,** French,
1811–1877

Gilman Collection,
Purchase, Howard
Gilman Foundation Gift,
2004 2004.106

20_ _ _____

20_ _ _____ 20_ _ _____

_____ _____

_____ _____

_____ _____

20_ _ _____ 20_ _ _____

_____ _____

_____ _____

_____ _____

Marble akroterion

Greek, ca.
350–325 B.C.

Rogers Fund, 1920
20.198

20__ _____

20__ _____ 20__ _____

_____ _____

_____ _____

_____ _____

20__ _____ 20__ _____

_____ _____

_____ _____

_____ _____

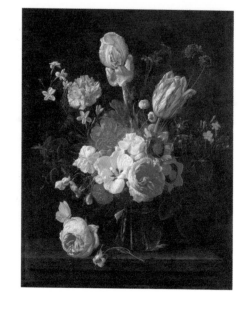

*A Bouquet of
Flowers in a
Crystal Vase*

**Nicolaes van
Veerendael,**
Flemish, 1640–1691

Bequest of Stephen
Whitney Phoenix, 1881
81.1.652

20__ _____

20__ _____ 20__ _____

_____ _____

_____ _____

_____ _____

20__ _____ 20__ _____

_____ _____

_____ _____

_____ _____

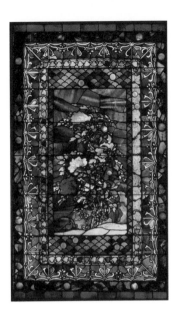

*Peonies Blown
in the Wind*

John La Farge,
American, 1835–1910

Gift of Susan Dwight Bliss,
1930 30.50

NOVEMBER | 30

20__ _____

20__ _____ 20__ _____

_____ _____

_____ _____

_____ _____

20__ _____ 20__ _____

_____ _____

_____ _____

_____ _____

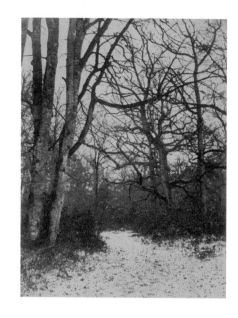

[Fontainebleau Forest]

Eugène Cuvelier,
French, 1837–1900

Purchase, The
Horace W. Goldsmith
Foundation Gift,
through Joyce and
Robert Menschel, 1987
1987.1036.1

20＿＿ _____

20＿＿ _____ 20＿＿ _____

_____ _____

_____ _____

_____ _____

20＿＿ _____ 20＿＿ _____

_____ _____

_____ _____

_____ _____

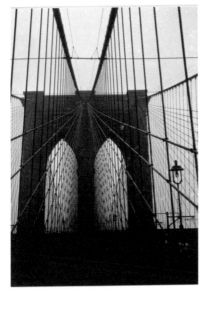

*[Brooklyn Bridge,
New York]*

Walker Evans,
American, 1903–1975

Gift of Arnold Crane,
2003 2003.564.1

© Walker Evans Archive, The
Metropolitan Museum of Art

20_ _ _____

20_ _ _____ 20_ _ _____

_____ _____

_____ _____

20_ _ _____ 20_ _ _____

_____ _____

_____ _____

Still Life—Violin and Music

William Michael Harnett,
American,
1848–1892

Catharine Lorillard Wolfe Collection, Wolfe Fund, 1963 63.85

20__ _____

20__ _____ 20__ _____

_____ _____

_____ _____

_____ _____

20__ _____ 20__ _____

_____ _____

_____ _____

_____ _____

"The Gould" Violin
Antonio Stradivari,
Italian, 1644–1737

Gift of George Gould,
1955 55.86 a-c

20_ _ _____

20_ _ _____ 20_ _ _____

_____ _____

_____ _____

20_ _ _____ 20_ _ _____

_____ _____

_____ _____

Still Life with Cake
Raphaelle Peale, American, 1774–1825

Maria DeWitt Jesup Fund, 1959 59.166

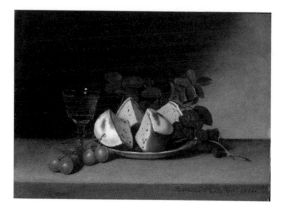

20__ _____

20__ _____ 20__ _____

_____ _____

_____ _____

_____ _____

20__ _____ 20__ _____

_____ _____

_____ _____

_____ _____

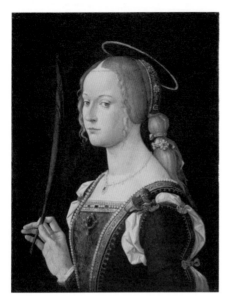

*Saint Justina
of Padua*

**Bartolomeo Montagna
(Bartolomeo Cincani),**
Italian, before 1459–1523

Bequest of Benjamin Altman,
1913 14.40.606

20＿＿ _____

20＿＿ _____

20＿＿ _____

20＿＿ _____

20＿＿ _____

***Tile with Floral and
Cloud-band Design***

Turkish (Iznik), ca.
1578

Gift of William B. Osgood
Field, 1902 02.5.91

20＿＿ _____

20＿＿ _____ 　　20＿＿ _____

_____ 　　_____

_____ 　　_____

_____ 　　_____

20＿＿ _____ 　　20＿＿ _____

_____ 　　_____

_____ 　　_____

_____ 　　_____

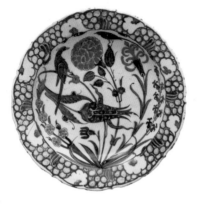

***Dish Depicting
Two Birds Among
Flowering Plants***

Turkish (Iznik), ca.
1575–1590

Gift of James J. Rorimer
in appreciation of Maurice
Dimand's curatorship,
1933–1959, 1959 59.69.1

20__ _____

20__ _____ 20__ _____

_____ _____

_____ _____

_____ _____

20__ _____ 20__ _____

_____ _____

_____ _____

_____ _____

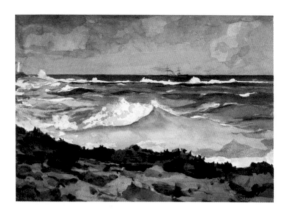

Shore and Surf, Nassau
Winslow Homer, American, 1836–1910
Amelia B. Lazarus Fund, 1910 10.228.5

20__ _____

20__ _____ 20__ _____

_____ _____

_____ _____

_____ _____

20__ _____ 20__ _____

_____ _____

_____ _____

_____ _____

Under the Wave off Kanagawa (Kanagawa oki nami ura), also known as The Great Wave, from the series *Thirty-six Views of Mount Fuji*

Katsushika Hokusai, Japanese, 1760–1849

boilerplate collection line

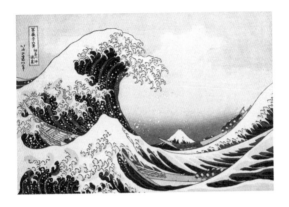

20__ _____

20__ _____ 20__ _____

_____ _____

_____ _____

_____ _____

20__ _____ 20__ _____

_____ _____

_____ _____

_____ _____

The Creation of the World and the Expulsion from Paradise
Giovanni di Paolo, Italian, 1398–1482
Robert Lehman Collection, 1975 1975.1.31

20___ _____

20___ _____ 20___ _____

_____ _____

_____ _____

_____ _____

20___ _____ 20___ _____

_____ _____

_____ _____

_____ _____

Armorial Plate (tondino): The Story of King Midas
Nicola da Urbino, Italian, active by 1520–died 1537/38

20__ _____

20__ _____ 20__ _____

_____ _____

_____ _____

_____ _____

20__ _____ 20__ _____

_____ _____

_____ _____

_____ _____

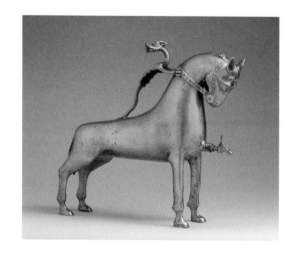

Aquamanile in the Form of a Horse
German, ca. 1400
Gift of William M. Laffan, 1910 10.13.4a

20_ _ _____

20_ _ _____ 20_ _ _____

_____ _____

_____ _____

_____ _____

20_ _ _____ 20_ _ _____

_____ _____

_____ _____

_____ _____

*Illustration for
"La Belle Vassilissa"
[The Red Knight
passes Vassilissa in
the Forest]*

Boris Zvorykin,
Russian, 1872–1942

Gift of Thomas H. Guinzburg,
The Viking Press, 1979
1979.53.7.12

20__ _____

20__ _____ 20__ _____

_____ _____

_____ _____

_____ _____

20__ _____ 20__ _____

_____ _____

_____ _____

_____ _____

Snow Scene

Bruce Crane, American, 1857–1937

George A. Hearn Fund, 1968 68.40

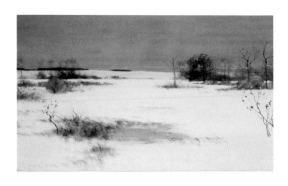

20__ __ _____

20__ __ _____ 20__ __ _____

_____ _____

_____ _____

20__ __ _____ 20__ __ _____

_____ _____

_____ _____

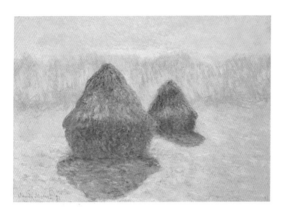

Haystacks (Effect of Snow and Sun)
Claude Monet, French, 1840–1926

H. O. Havemeyer Collection, Bequest of Mrs. H. O.
Havemeyer, 1929 29.100.109

20__ _____

20__ _____ 20__ _____

_____ _____

_____ _____

_____ _____

20__ _____ 20__ _____

_____ _____

_____ _____

_____ _____

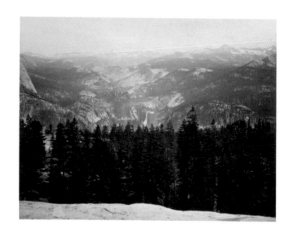

View from the Sentinel Dome, Yosemite
Carleton E. Watkins, American, 1829–1916
Purchase, Joseph Pulitzer Bequest, 1989 1989.1084.1

20＿＿ _____

20＿＿ _____ 20＿＿ _____

_____ _____

_____ _____

_____ _____

20＿＿ _____ 20＿＿ _____

_____ _____

_____ _____

_____ _____

20__ _____

20__ _____ 20__ _____

_____ _____

_____ _____

_____ _____

20__ _____ 20__ _____

_____ _____

_____ _____

_____ _____

The Octopus

**Alvin Langdon
Coburn,** British,
1882–1966

Ford Motor Company
Collection, Gift of Ford
Motor Company and
John C. Waddell, 1987
1987.1100.13

20__ _____

20__ _____ 20__ _____

_____ _____

_____ _____

_____ _____

20__ _____ 20__ _____

_____ _____

_____ _____

_____ _____

The Boulevard Montmartre on a Winter Morning
Camille Pissarro, French, 1830–1903

Gift of Katrin S. Vietor, in loving memory of Ernest G. Vietor, 1960 60.174

20__ _____

20__ _____ 20__ _____

_____ _____

_____ _____

_____ _____

20__ _____ 20__ _____

_____ _____

_____ _____

_____ _____

Evening Snow at Kanbara, from the series "Fifty-three Stations of the Tōkaidō"

Utagawa Hiroshige, Japanese, 1797–1858

The Howard Mansfield Collection, Purchase, Rogers
Fund, 1936 JP2492

20＿＿ ＿＿＿＿＿＿＿＿＿＿＿＿＿＿＿＿
＿＿＿＿＿＿＿＿＿＿＿＿＿＿＿＿＿＿＿＿＿＿＿
＿＿＿＿＿＿＿＿＿＿＿＿＿＿＿＿＿＿＿＿＿＿＿

20＿＿ ＿＿＿＿＿＿＿＿＿ 20＿＿ ＿＿＿＿＿＿＿＿＿
＿＿＿＿＿＿＿＿＿＿＿＿＿ ＿＿＿＿＿＿＿＿＿＿＿＿＿
＿＿＿＿＿＿＿＿＿＿＿＿＿ ＿＿＿＿＿＿＿＿＿＿＿＿＿
＿＿＿＿＿＿＿＿＿＿＿＿＿ ＿＿＿＿＿＿＿＿＿＿＿＿＿

20＿＿ ＿＿＿＿＿＿＿＿＿ 20＿＿ ＿＿＿＿＿＿＿＿＿
＿＿＿＿＿＿＿＿＿＿＿＿＿ ＿＿＿＿＿＿＿＿＿＿＿＿＿
＿＿＿＿＿＿＿＿＿＿＿＿＿ ＿＿＿＿＿＿＿＿＿＿＿＿＿
＿＿＿＿＿＿＿＿＿＿＿＿＿ ＿＿＿＿＿＿＿＿＿＿＿＿＿

Rue Eugène Moussoir at Moret: Winter
Alfred Sisley, British, 1839–1899
Bequest of Ralph Friedman, 1992 1992.366

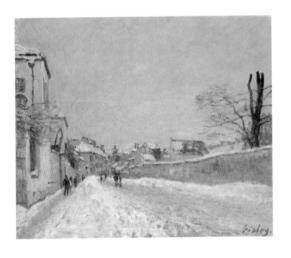

20_ _ _____

20_ _ _____ 20_ _ _____

_____ _____

_____ _____

_____ _____

20_ _ _____ 20_ _ _____

_____ _____

_____ _____

_____ _____

Central Park, Winter
William James Glackens, American, 1870–1938

George A. Hearn Fund, 1921 21.164

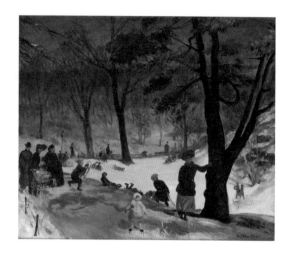

20__ _____

20__ _____ 20__ _____

_____ _____

_____ _____

_____ _____

20__ _____ 20__ _____

_____ _____

_____ _____

_____ _____

Central Park, Winter — The Skating Pond
After a painting by Charles Parsons, American (b. England), 1821–1910
Lithographed by Lyman W. Atwater, American, 1835–1891
Published and printed by Currier & Ives, American, active 1857–1907

Bequest of Adele S. Colgate, 1962 63.550.266

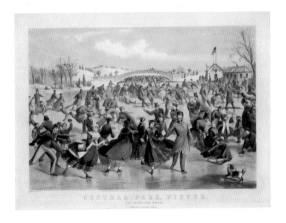

20__ _____

20__ _____ 20__ _____

_____ _____

_____ _____

20__ _____ 20__ _____

_____ _____

_____ _____

The Adoration of the Christ Child

Follower of Jan Joest of Kalkar, Netherlandish, active ca. 1515

The Jack and Belle Linsky Collection, 1982 1982.60.22

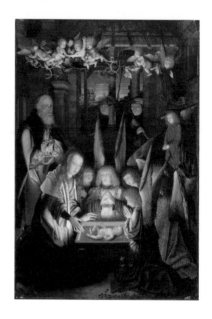

20__ _____

20__ _____ 20__ _____

20__ _____ 20__ _____

The Brioche
Édouard Manet, French, 1832–1883

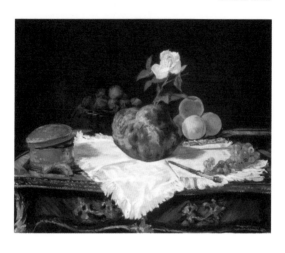

20_ _ _____

20_ _ _____ 20_ _ _____

_____ _____

_____ _____

_____ _____

20_ _ _____ 20_ _ _____

_____ _____

_____ _____

_____ _____

[Snow Crystal]

Wilson Alwyn Bentley, American, 1865–1931

Josh Rosenthal Fund, 2005 2005.55.3

20___ _____

20___ _____ 20___ _____

_____ _____

_____ _____

_____ _____

20___ _____ 20___ _____

_____ _____

_____ _____

_____ _____

20__ _____

20__ _____ 20__ _____

_____ _____

_____ _____

_____ _____

20__ _____ 20__ _____

_____ _____

_____ _____

_____ _____

*Making a
Snow-lion*

Yu Ming, Chinese,
1884–1935

Gift of Robert Hatfield
Ellsworth, in memory
of La Ferne Hatfield
Ellsworth, 1986
1986.267.147

20_ _ _____

20_ _ _____ 20_ _ _____

20_ _ _____ 20_ _ _____

Polar Bear

François Pompon,
French, 1855–1933

Purchase, Edward C. Moore Jr.
Gift, 1930 30.123ab

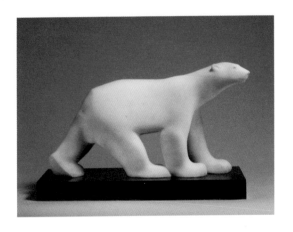

20__ _____

20__ _____ 20__ _____

_____ _____

_____ _____

_____ _____

20__ _____ 20__ _____

_____ _____

_____ _____

_____ _____

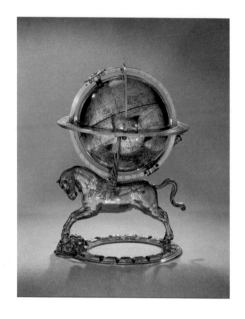

*Celestial Globe
with Clockwork*

**Gerhard
Emmoser,**
German, active
1556–1584

Gift of J. Pierpont
Morgan, 1917 17.190.636

20__ __ _____

20__ __ _____ 20__ __ _____

_____ _____

_____ _____

_____ _____

20__ __ _____ 20__ __ _____

_____ _____

_____ _____

_____ _____